Oil Painting for the Absolute Beginner

A Clear & Easy Guide to Successful Oil Painting

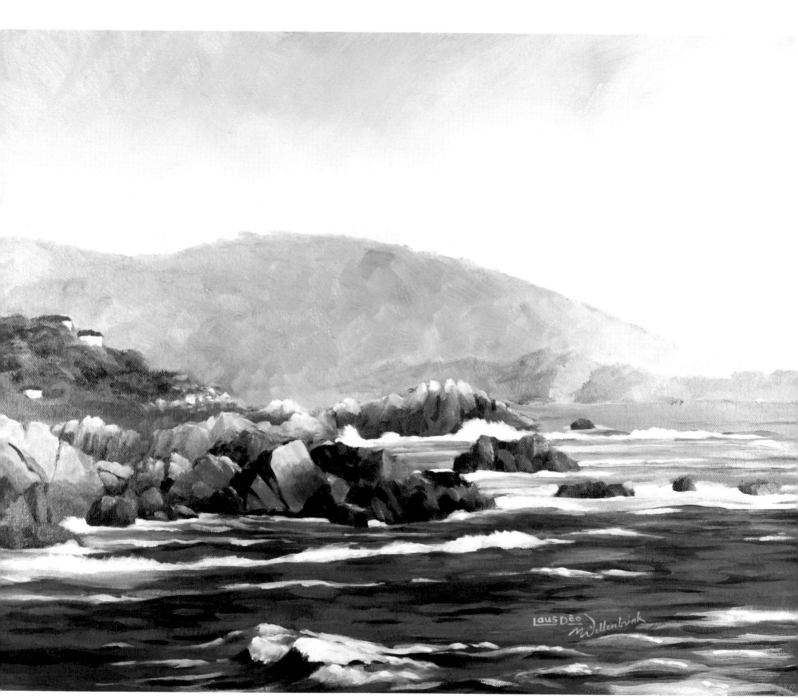

California Surf
oil on stretched canvas
16" × 20" (41cm × 51cm)

oil painting for the
absolute beginner

A Clear & Easy Guide to
Successful Oil Painting

Mark and Mary
Willenbrink

NORTH LIGHT BOOKS
CINCINNATI, OHIO
www.artistsnetwork.com

About the Authors

As a husband-and-wife team, Mark and Mary Willenbrink have been writing together for over a decade. Mark works as a fine artist, illustrator and art instructor. Mary is an author, literary analysis teacher and homeschool mom. Mark and Mary's art instruction focuses on the needs of the absolute beginner. Mark's art and teaching expertise along with Mary's encouragement and understanding provide the perfect balance for those just embarking on their artistic journey. Mark and Mary's other books include *Watercolor for the Absolute Beginner* and *Drawing for the Absolute Beginner*. Mark and Mary reside in Cincinnati, Ohio, with their three children, two cats and Australian shepherd.

To see more of Mark's artwork, visit his website at www.shadowblaze.com.

Oil Painting for the Absolute Beginner: A Clear & Easy Guide to Successful Oil Painting. Copyright © 2010 by Mark and Mary Willenbrink. Manufactured in China. All rights reserved. No part of this book may be reproduced in any form or by any electronic or mechanical means including information storage and retrieval systems without permission in writing from the publisher, except by a reviewer who may quote brief passages in a review. Published by North Light Books, an imprint of F+W Media, Inc., 4700 East Galbraith Road, Cincinnati, Ohio, 45236. (800) 289-0963. First Edition.

Other fine North Light Books are available from your local bookstore, art supply store or online. Also visit our website at www.fwmedia.com.

14 13 12 11 10 5 4 3 2 1

DISTRIBUTED IN CANADA BY FRASER DIRECT
100 Armstrong Avenue
Georgetown, ON, Canada L7G 5S4
Tel: (905) 877-4411

DISTRIBUTED IN THE U.K. AND EUROPE BY DAVID & CHARLES
Brunel House, Newton Abbot, Devon, TQ12 4PU, England
Tel: (+44) 1626 323200, Fax: (+44) 1626 323319
Email: postmaster@davidandcharles.co.uk

DISTRIBUTED IN AUSTRALIA BY CAPRICORN LINK
P.O. Box 704, S. Windsor NSW, 2756 Australia
Tel: (02) 4577-3555

Library of Congress Cataloging-in-Publication Data
Willenbrink, Mark
 Oil painting for the absolute beginner : a clear & easy guide to successful oil painting / by Mark and Mary Willenbrink. -- 1st ed.
 p. cm.
 Includes index.
 ISBN 978-1-60061-784-3 (pbk. : alk. paper)
 1. Painting--Technique. I. Willenbrink, Mary II. Title. III. Title: Clear & easy guide to successful oil painting. IV. Title: Clear and easy guide to successful oil painting.
 ND1473.W55 2010
 751.45--dc22 2010005056

Edited by Mary Burzlaff Bostic
Designed by Guy Kelly
Production coordinated by Mark Griffin

Metric Conversion Chart

To convert	to	multiply by
Inches	Centimeters	2.54
Centimeters	Inches	0.4
Feet	Centimeters	30.5
Centimeters	Feet	0.03
Yards	Meters	0.9
Meters	Yards	1.1

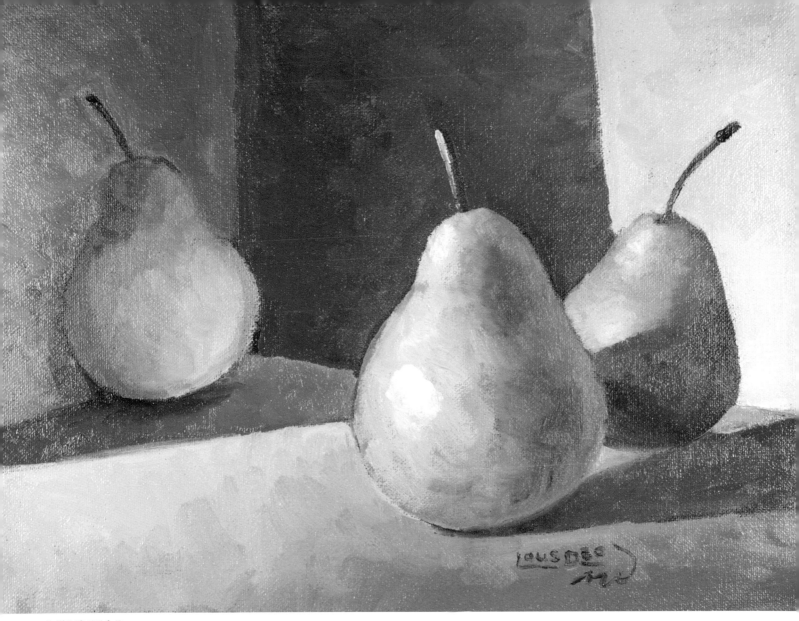

Still Life With Pears
oil on canvas mounted on board
9" × 12" (23cm × 30cm)

Acknowledgments

Thank you to all of those behind the scenes at F+W Media who helped put this beautiful book and DVD together: Guy Kelly, Mark Griffin, Jennifer Lepore, Ric Deliantoni and Adam Hand.

We give special thanks to our editor, Mary Bostic. Because of your editorial insights and questions, this book is just about perfect!

Thank you, Tom Post, for your encouragement and advice, and thanks to Cheryl and Jeff Cook. We thank everyone with Heavenly C Ministries for your encouragement and constant support.

The support of our kids as we work is absolutely amazing. With great pride and our utmost love, we thank our three children.

Throughout the writing of this book, we constantly thanked each other. As a husband-and-wife team, we bring out the best in each other and can honestly say we are best friends.

Lastly, we thank the Lord for His inspiration. We are all created in our Father's image to be creative, and with our creativity we praise Him.

Dedication

We dedicate this book to Clare Willenbrink and Grace Patton, our greatest encouragers.

Contents

Introduction

During an outdoor celebration our eldest daughter exclaimed, "Ooh, look at the fireworks," to which our youngest child gleefully replied, "Those aren't fireworks, they're dancing bananas!" How fun! Their perceptions are unique, yet both are filled with wonder. Wouldn't you love to see their artistic expressions of fireworks?

Capture that feeling of curiosity and excitement as you work through this book, using the lessons as a tool to express yourself through your artwork. Then allow yourself to stand back from your paintings and say something like "Ooh, I love the reflections in this pond" or "I really like the way I painted those trees." Don't be overly critical of your work. Note what you like about it, and always date the painting so that you can follow your progress.

First Things First

We suggest you go through the materials and take time to set up your own studio. Our definition of *studio* is a space that transports you away from the concept of time, responsibilities and worries. Each time you pick up this book, prepare yourself to be an active participant. Start reading it as if we were speaking to you directly. We hope that as you work through these demonstrations, you will cultivate your abilities while having fun in the process. Seriously, we want you to have fun!

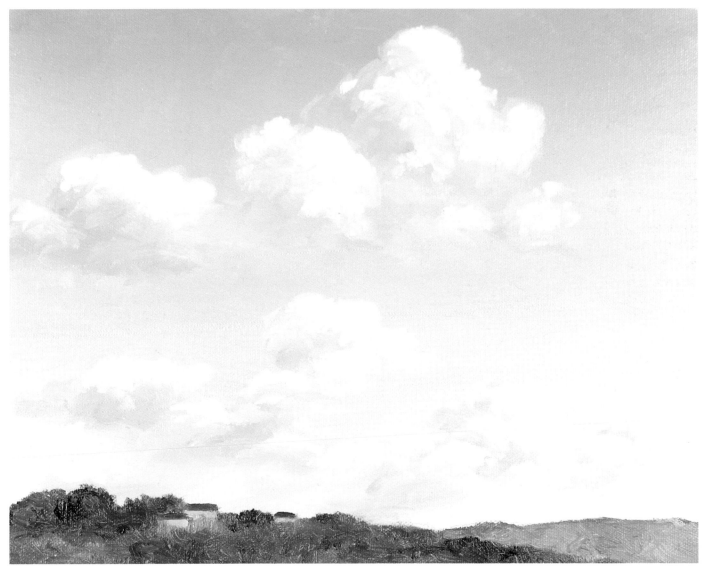

Clouds Over Tuscany
oil on canvas mounted on board
8" × 10" (20cm × 25cm)

1 Gather Your **Materials**

Oil paintings have a timeless quality. They are durable and fun to work with. There's nothing like mixing the smooth, buttery consistency of the paints on your palette until you have just the right colors for your painting. Whatever the project, you need the right tools to accomplish your task. This chapter will explore the many painting supplies available and will help you find the right supplies for an enjoyable and successful painting experience.

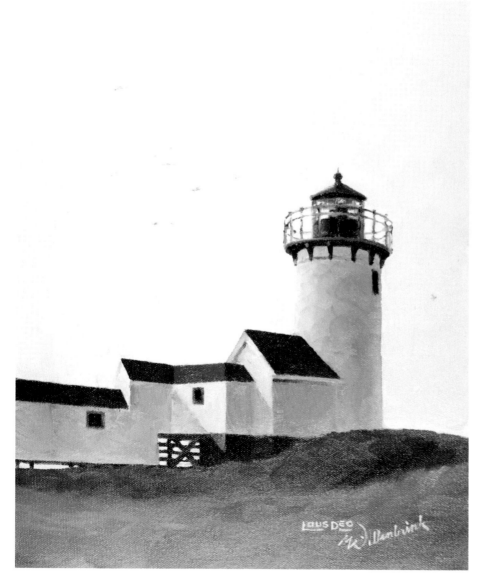

North Point Light
oil on stretched canvas
14" × 11" (36cm × 28cm)

Paints

A variety of oil paints is available on the market. The differences among them can affect performance, price and even your health.

Oil Paint 101

Oil paint is made from a combination of pigment (the color) and oil (the binder). Some paints have wax or filler additives. Years ago, pigments consisted mostly of natural substances. Now, most contemporary paints use synthetic pigments, which are cheaper to produce and have better lightfastness (resistance to fading). Linseed oil is commonly used as the binder, though other oils, such as safflower, sunflower, poppy or walnut oil, may be used. Some pigments, such as cadmium, may be toxic. Follow the manufacturer's guidelines and warnings.

Traditional vs. Water-Soluble Paints

Most traditional oil paints require turpentine or mineral spirits to thin the paints and clean the brushes. The smell of these solvents can be overpowering, and contact or inhalation are health hazards, even with the "odorless" types. There is also the issue of how to dispose of used solvents. What happens if you dump that stuff down a drain?

Water-soluble (water-mixable) oil paints are made of pigment and oil like traditional oil paints, but the oil has been chemically modified to allow the paints to dissolve in water instead of in smelly, toxic solvents. With the performance of water-soluble oils matching that of traditional oils, more people will be free to work with oils who were previously unable to because of health concerns.

Go Green!
Water-soluble paint brands include Max Grumbacher, Holbein Duo Aqua Oil, Winsor & Newton Artisan and Van Gogh H2Oil.

Grade

Oil paints are available in student grade or professional (also known as artist) grade. Student grade paints are less expensive, but professional paints contain more pigment and have more intense colors.

Lightfastness

You've probably seen an old poster that has faded so that only the blue and black colors remain. Reds and yellows are more prone to fading, especially if left in direct sunlight. Manufacturers often rate the degree of lightfastness, the resistance to fading, on the paint tube.

Tip

If you want a good palette but are price conscious, you might consider purchasing professional grade paints for the brighter colors and student grade paints for the neutral colors.

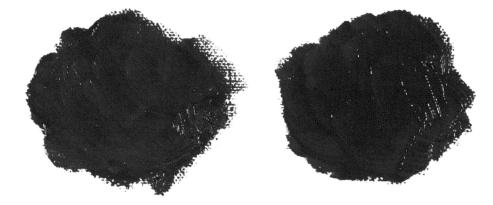

Professional or Student Grade
The professional grade Winsor & Newton Permanent Rose on the left is slightly brighter and more pure in color than the student grade Van Gogh H2Oil Quinacridone Rose on the right.

Weird But True!

All sorts of materials have been ground for use as pigments for paints, many of which have been replaced by synthetic pigments. Some of the more unusual substances include semiprecious stones, mummies and dried urine from cows fed on mango leaves.

Solvents and Thinners

Solvents and thinners are liquids used to thin and dissolve paint. Artists add them to the paints during the painting process to thin the paints and also to release the paint from the brushes and clean the palette.

Mediums

Mediums are liquids or gels that can be added to the paint to change its characteristics. Depending on the medium used, they can speed up or slow down the drying time, improve the flow, affect the consistency and increase the gloss and transparency of the paint.

For a quick study, a painting completed in a few hours, it may not be necessary to add medium to your paint as you work. For longer studies, during which the paint might begin to dry, add a slight amount of medium to the paint so that each layer has more oil (medium) than the previous layer. This technique is called "fat over lean." The first layers of applied paint should dry sooner than the later layers of paint. This decreases the risk of cracking and flaking over time.

Some artists prefer to make their own mediums by combining oils, solvents and varnishes. However, creating the perfect balance can be tricky. If you add too much oil, the paint may discolor. If you add too much solvent, the paint may become too lean. Adding varnish may make the paint tacky and hard to rework. Mixing varnish with the paint may also cause some of the paint to be removed if the painting is cleaned at a later date. I prefer using premade mediums and recommend them for more consistent results.

Hazardous to Your Health

The most common solvents or thinners for traditional oils are turpentine (distilled tree resin) and mineral spirits (distilled petroleum). Even the odorless types of these solvents pose health hazards with contact and inhalation. They are also flammable.

Water-soluble oil paints dissolve in water and don't require hazardous solvents, so toxic fumes are no longer an issue. Water can be used to thin water-soluble paints, but paint manufacturers also sell thinners for these paints. Those thinners have a consistency that is slightly thicker than water and can improve the flow of the paint. Brushes used with water-soluble paint can be cleaned with soap and water. Commercially made brush cleaner can also be used to thoroughly clean the brushes.

Solvents/Thinners and Mediums
Solvents/thinners and mediums are available for both traditional oil paints and water-soluble paints. Water-soluble paints do not require any solvent/thinner except water.

Palettes

Palettes are used for holding and mixing paints and are usually made of a thin piece of wood or plastic. They come in a variety of shapes and sizes. Ideally, a palette should be large enough for mixing and holding lots of paint but not so big that it feels awkward and cumbersome. (I usually hold the palette in my hand as I paint.) Many travel easels, such as French easels, include a rectangular wooden palette that fits neatly within the closed box unit.

Oil paints aren't reusable once they have dried on the palette. To clean the palette, scrape off the old paint with a palette knife and wipe it off with a rag before each painting session.

Palette pads are a disposable alternative to regular palettes. The pad is made of thick, coated white paper. After your painting session, you can tear off the top sheet and discard it along with the old paint. Palette pads are available in rectangular- and oval-shaped pads and have a thumb hole so they can be held like traditional palettes.

Palette Cups

Palette cups are small reservoirs that attach to a palette to hold solvents, thinners and mediums. You may not need palette cups since you can use the solvent (or water) contained in the brush wash as thinner, and most of our demonstrations can be completed in one session and thus won't require medium (medium is used when layering new paint on top of dried paint).

Palette Options
Palettes are available in different shapes, sizes and materials. You can find them made from wood, plastic, Masonite and even glass.

Palette Knives
Palette knives are useful for scraping old paint off palettes and sometimes off brushes that have become clogged with paint.

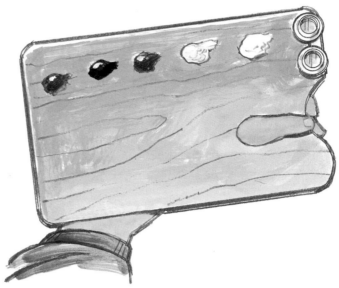

Palette Pads

Palette pads offer easy cleanup. Just tear off and throw away the top sheet when you're finished with your painting session.

Holding the Palette

It's typical to stand while oil painting, holding the palette in one hand. Because I paint with my right hand, I hold the palette with my left hand, thumb through the hole and cradled on my left arm. Avoid getting paint on your arm or sleeve by keeping the paint away from the lower edge of the palette.

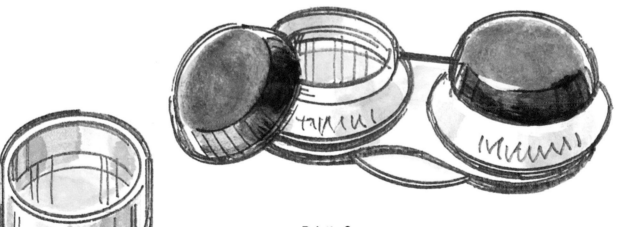

Palette Cups

Palette cups are available in metal or plastic, with or without lids. The lids protect the fluid from dust until your next painting session. You can buy single or twin cups. If using twin cups, labeling the cups will help you avoid confusing the solvent/thinner and the medium. The palette cups can be clipped on the side of your easel.

Surfaces

There are many options when it comes to painting surfaces, also called supports. The surface you choose depends on your preference and desired results.

Stretched canvas is the most common oil painting surface. This type of canvas is stretched across a frame of stretcher bars (the wooden pieces that the canvas is attached to). For large canvases, it's good to have strong, sturdy stretcher bars. Canvas is available in cotton or linen. While cotton is less expensive, it may not remain as taut as linen over time. There is also a range of different textures. The smoothness of a fine-weave canvas works best for delicate paintings such as a detailed portrait, while the coarseness of a rough-weave canvas is best for paintings that require thick layers of paint.

Manufactured stretch canvases usually come primed and are ready for the artist to begin oil painting. Stretched canvases are recommended for large paintings because they are relatively lightweight for their size.

Masonite and plywood panels are available primed and ready to use, or you can make your own. Relatively inexpensive, these panels are good for smaller paintings.

Masonite and plywood panels can also be bought with canvas glued to one side. These panels provide the genuine canvas texture along with the rigidness of Masonite or plywood board.

Cradled Masonite and plywood panels have a wood frame on the back. The wood frame "cradles" the panel, making it sturdier and less prone to warping.

Canvas-wrapped panels are made of Masonite, plywood or cardboard, and are wrapped with a primed canvas. They are similar to panels with canvas glued to one side. However, if the core is made of cardboard, the panel may swell and warp over time.

Canvas pads are sheets of primed canvas in pad form. These sheets are especially good for practice sessions. Just cut the sheet to the size you want and use Bulldog clamps to attach the canvas to a Masonite board.

Make Your Own

You can make your own painting surfaces from ⅛-inch (3mm) Masonite or ¼-inch (6mm) birch plywood panels. First, sand the surface with sandpaper. This will roughen the surface so that the gesso will adhere. Then apply three coats of gesso, painting the first coat side to side, the second coat up and down, then the third coat side to side. This will mimic the texture of canvas. You can also apply gesso in an irregular pattern to create an uneven surface texture. Covering the back of the panel with gesso will help prevent warping.

Applying Gesso to Unprimed Canvas

Using an ordinary house paint brush, apply two or three coats of gesso, alternating your strokes with each coat for your desired effect. Follow the manufacturer's instructions on the gesso container.

Adding Wedges to Tighten a Canvas

If a canvas appears loose, insert wooden corner wedges into the inside corner slots of the stretcher bars. This may be done long after a painting is completed to tighten a stretched canvas that is loose and saggy.

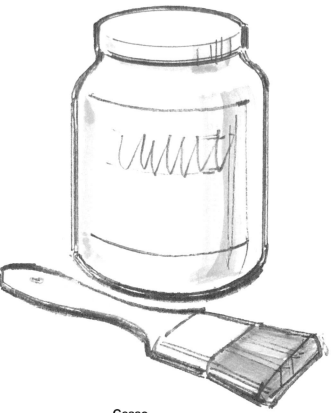

Gesso
No matter the type, all unprimed surfaces need to be coated with gesso. Otherwise, the paint may not hold up over time. Gesso is a liquid or gel that can be painted onto the surface with a house paint brush. Acrylic gesso primer works with oil paints and is easy to clean off brushes. Gesso is usually white, but it's also available clear or colored.

Stretching Canvas
MINI DEMONSTRATION

Though it can be costly, some artists prefer to stretch their own canvases. By stretching the canvas themselves, they have control over the type of canvas, the stretcher bars and the application of the gesso.

Materials

Supplies
4 stretcher bars, canvas, staple gun with staples, canvas pliers

Optional Supplies
gesso, house paint brush, wedges

1 Assemble the Stretcher Bars and Cut the Canvas

Fit together the four stretcher bars. Make sure the distance between diagonal corners is equal to ensure that it's square.

Lay the canvas face down on a clean surface. Place the stretcher bars front side down onto the canvas, lining up the weave of the canvas with the stretcher bars. Cut the canvas 3–4 inches (8–10cm) beyond the sides of the stretcher bars.

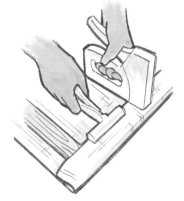

2 Attach the Top and Bottom of the Canvas to the Stretcher Bars

Fold the top of the canvas over the top stretcher bar and staple it into the center of the stretcher bar.

Fold the bottom end of the canvas over the bottom stretcher bar. Pull it taut with the canvas pliers and staple into the center of the stretcher bar. Don't overstretch. Unprimed canvas will shrink after you apply the gesso.

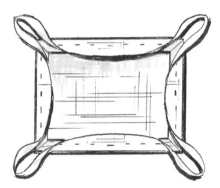

3 Attach the Left and Right Sides and Continue Stapling

Using a single staple for each side, repeat this process to attach the left and right sides of the canvas to the stretcher bars.

While pulling the canvas with the pliers, staple 2 inches (5cm) to the left and to the right of the top center staple. Repeat with the bottom and sides. Continue stapling in this fashion, two at a time at each side, stopping 3 inches (8cm) from the corners.

4 Fold and Staple the Canvas Corners

Fold and staple the canvas at the top left corner. Smooth out the canvas on the side bar. Pull the canvas taut and staple once near the corner.

5 Make a Double Fold

Make a double fold with the canvas at the top left corner.

6 Flatten the Canvas and Staple

Press the canvas flat and staple to finish the top left corner.

7 Repeat to Finish the Corners

Repeat steps 4–6 for the three remaining corners so that the folds at the opposite corners mirror each other for a nice, symmetrical appearance.

Brushes

Oil painting brushes are available in a variety of shapes, sizes and hair types. It's good to have a range of brushes. During the painting process, you'll usually use the largest brushes first, then the smaller brushes, working your way to the smallest brush for your final details.

Brush Shapes

Flats have a wide, flat set of hairs that are squared at the end. These range from large house painting brushes for putting down lots of paint to much smaller brushes for chiseling in details. Flat brushes with short, stubby hairs are also referred to as brights. These brushes are stiffer and hold less paint.

Filberts are similar to flats, but their ends are rounded and may come to a point. The brushstrokes made by filberts tend to be less harsh than those of flat brushes. I paint primarily with filberts.

Rounds have a round body of hairs that come to a point. I use these brushes mostly for details.

Riggers (also called scripts or liners) are like round brushes, but they have long, slender hairs for making long brushstrokes. They're useful for signing your paintings.

Hair Types

Brush hairs affect the way paint applies to the painting surface. Two common types of hair are coarse bristle and fine hair.

Coarse bristle brushes are made of hog hair and are durable and easy to clean. Their firmness and ability to hold lots of thick paint allow for vigorous, textural brushstrokes. For this book, you will mainly want to use coarse bristle brushes.

Fine hair brushes are made of natural sable hairs, synthetic hairs or a combination of the two. Their soft hairs provide smooth painting results and are good for thin paint applications, detail work and signing your paintings.

Hair Length

Short-haired brushes are stiffer than their long-haired counterparts. Long-haired brushes are good for holding more paint.

Handle Length

Long-handled brushes are good for standing back from the painting to make loose, quick strokes. Short-handled brushes are useful for closer, more detailed painting.

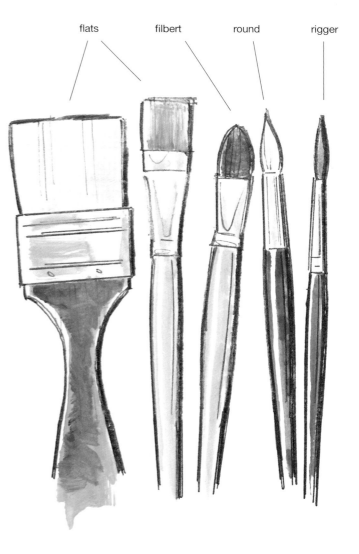

flats filbert round rigger

Choosing a Good Brush

Good brushes are firm, yet have spring so that they return to their original shape. Expensive brushes are nice but aren't always necessary. You can compile an assortment of less-expensive brushes that are just as well suited for your painting experience. However, avoid inferior brushes with hairs that fall out, fray or lose their shape. Aside from following personal recommendations, the only way to find inexpensive, good-quality brushes is through trial and error.

Brush Care and Use

Even the best brushes can fall apart and lose their shape if not maintained properly. Clean brushes thoroughly after each painting session so that they keep their shape and springiness. If the paint dries on them, it will make the bristles too stiff and unmanageable. Furthermore, you may never be able to revive the brush to its earlier condition and it could be ruined. While you want to clean the brushes thoroughly, be as gentle as possible, especially with sable and synthetic brushes. Bristle brushes are more durable and can accept rougher treatment. As you paint, you'll need to clean your brushes when you switch colors. Wipe the brush on a rag or paper towel to remove most of the paint, then use a brush wash to release any remaining paint.

Tips Tip

Never leave a brush standing on its hairs in a jar of solvent. This will eventually bend the tip into an unusable shape.

Using a Brush Wash

You can clean your paint brush by swishing it back and forth in solvent contained in a brush wash. Of course, if you are using the preferred water-soluble oils, water is used as the solvent. Brush washes have a metal screen or coil above the bottom of the jar so that the released paint settles to the bottom below the screen or coil. Dragging the brush along the screen/coil releases more paint from the brush.

When you are finished painting with your brushes for the day, clean them by hand with brush cleaner and reshape the hairs to their intended form. Brushes can be stored standing tip up or flat on their sides.

Brush Washes

Metal brush washes come in different sizes and are good for travel. Glass brush washes are small and can be used in the studio. Both come with lids and a metal screen or coil.

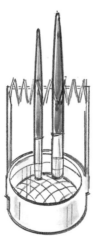

Brush Wash With Spiral Brush Holder

This type of brush wash allows brushes to hang upside down in the solvent without resting the hairs on the bottom of the jar. However, don't leave brushes in that position for too long because the fluid could work up to the wood handle, causing damage.

Storing Brushes

A bamboo brush holder allows brushes to dry from underneath even while lying on their sides. You can also roll your brushes up in this holder to protect them in storage or in transit.

Additional Supplies

Here are a few additional supplies I recommend for your oil painting sessions. You may not need all of these supplies for every demonstration. Before you start, check the materials list to make sure you have everything you need for a successful painting experience.

Palette Knives

Palette knives usually consist of a metal blade attached to a wooden handle. Though the handles are all about the same size and shape, the blades vary in shape, length and flexibility. Palette knives are useful for mixing paint and scraping paint off the palette. Sometimes artists even paint with them. I like to have a few different shapes on hand. Short, firm blades are good for cleaning the palette. Long, flexible blades are good for applying paint.

Rags and Paper Towels

Rags and paper towels can be used to clean brushes and for general cleanup.

Graphite and Charcoal Pencils

Some artists draw the image on the painting surface with graphite or charcoal pencils before applying paint.

Kneaded Eraser

This eraser doesn't crumble or streak like other erasers and can be used to erase unwanted pencil or charcoal lines.

Spray Fixative

If you draw with graphite or charcoal on the painting surface, fixative will keep the graphite or charcoal from smearing when you begin to paint.

Varnish

Varnish is a transparent liquid used to protect the painting and give it an even finish. Allow paintings to dry completely (six months to one year) before applying varnish. As always, follow the manufacturer's recommendations for proper use.

Mahlstick

A mahlstick, a metal or wood stick with a leather-covered cork at one end, is used as a hand rest to steady the painting hand. To use this tool, place the cork end on the edge of the painting surface, then rest your brush hand on the stick to keep it steady as you paint. This tool can be helpful for painting straight lines.

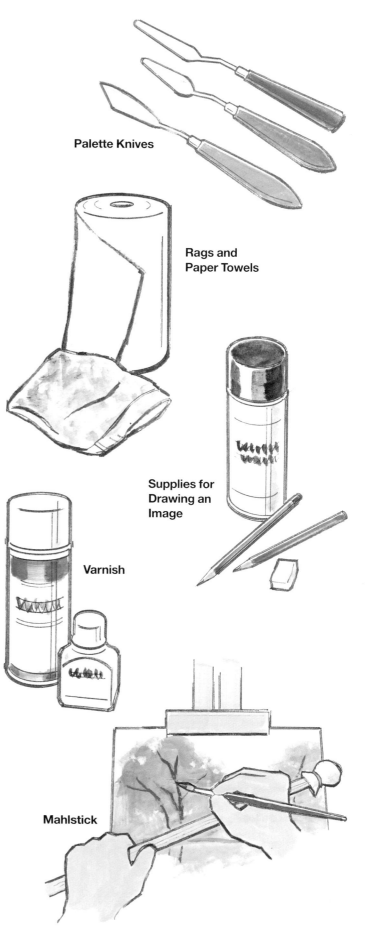

Palette Knives

Rags and Paper Towels

Supplies for Drawing an Image

Varnish

Mahlstick

Easels

Traditionally, artists stand while oil painting so they have freedom in their movements and a better view of their work. Easels securely hold paintings at the proper height and angle for this painting position. Easels vary in size and are generally constructed of wood or metal. Some easels are intended specifically for field use. Read on for descriptions of specific easel types.

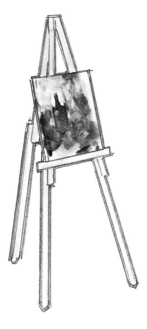

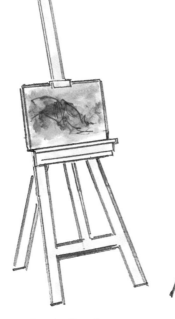

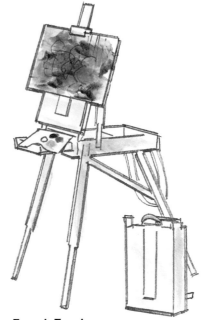

Wooden Student Easel
Although this economical easel looks adequate, you may be disappointed if you use it. Flimsy and lacking a top brace to hold the painting, this easel is not very practical.

Studio Easel
Intended for indoor use, these wood or metal easels range in sturdiness and simplicity of design. The most expensive can tilt and move the position of the painting surface, even accommodating more than one painting.

Field Easel
Field easels are lightweight and portable for outdoor use. The metal telescopic legs are similar in design to those of a camera tripod.

French Easel
The versatile French easel doubles as a carrying case for painting supplies, including a palette. Intended for outdoor painting, it can also be used indoors.

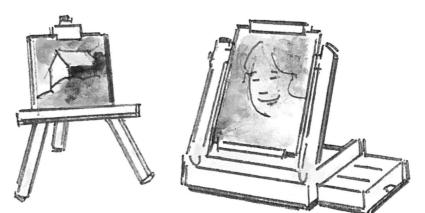

Table Easels
For use on a table, the box type is similar to a French easel but without legs. The table easel is sturdy and has a top brace to hold the painting in place.

Indoor Setup

Start simple and add the furnishings for a comfortable work environment that suits your personal painting preferences.

During the painting process, I continually pick up, put down and clean my brushes. I find it most practical to place the brushes I'm working with flat on the work surface so I can identify and keep track of them. The brush holder keeps them from rolling and allows them to dry.

Because I am right-handed, I keep most of my equipment on my right side. The painting surface works best when it is placed at eye level, with the reference photos attached to the easel or nearby for easy viewing. Though a taboret (a portable cabinet) is nice to have, a table at a comfortable height and storage shelves are sufficient. During a painting session, I may stand for hours at a time. The floor mat makes the experience more comfortable on the feet.

Painting in Style

If you don't want to wear a smock or apron, consider wearing old clothes that can get stained with smeared paint.

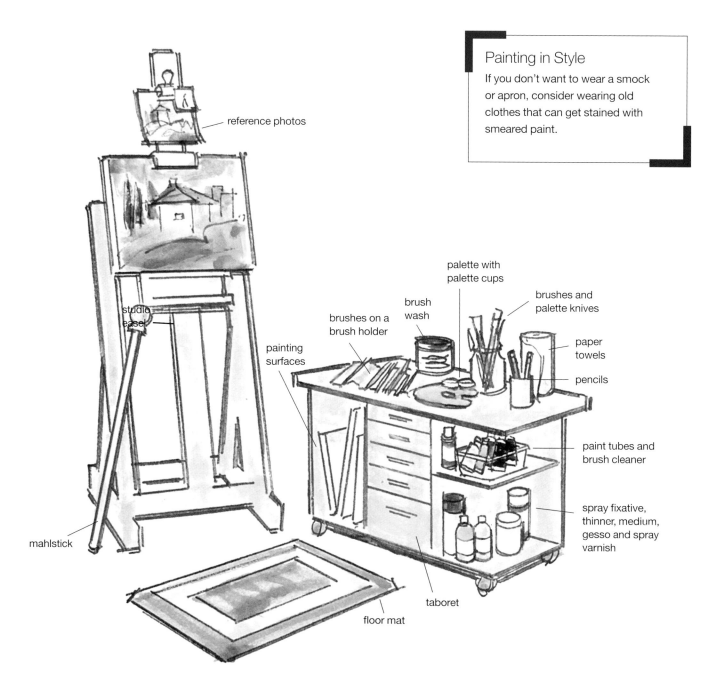

reference photos

studio easel

mahlstick

painting surfaces

brushes on a brush holder

brush wash

palette with palette cups

brushes and palette knives

paper towels

pencils

paint tubes and brush cleaner

spray fixative, thinner, medium, gesso and spray varnish

taboret

floor mat

Outdoor Setup

Painting outdoors (*en plein air*) is a great experience because it sharpens observational skills. When packing your supplies to carry to your site, a French easel can carry almost everything needed, including the painting surface and palette. French easels come in different sizes with optional accessories, including paper towel holder, shelves and even an umbrella. Use a convenient tote bag or carrying case if you do not have a French easel.

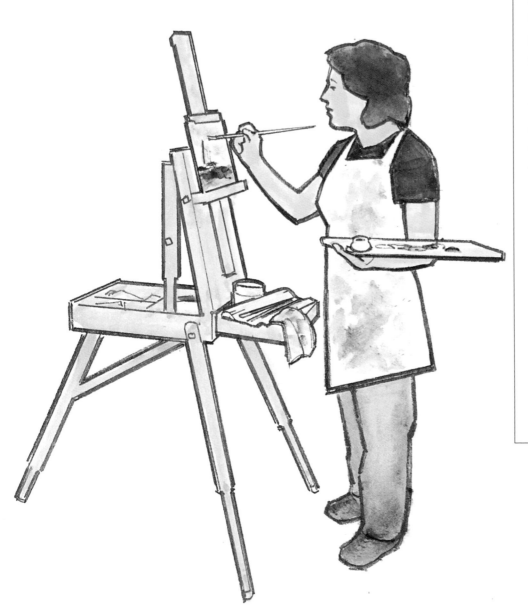

Outdoor Painting Supplies for Water-Soluble Oils

Many of these supplies can fit within a French easel.

Basic Supplies

paints

palette (usually included with French easel)

palette cup with thinner

painting surface

brushes

bamboo brush holder

brush wash with water

palette knife

rag or paper towels

Optional Supplies

extra water for brush wash

water to drink

mahlstick

sketchbook

pencils

camera

folding stool

smock or apron

Optional Easel Accessories

paper towel holder

umbrella

shelves

Discussing Materials

As you paint, you will likely develop a preference for a specific painting surface. Here are examples of oil paint on three different painting surfaces.

Stretched Canvas

Stretched canvas is lightweight and flexible. The drumlike surface makes for a springy feel. It may seem more difficult to control the brush on this giving surface than on a solid support surface. Stretched canvas paintings take up more storage space than paintings done on board.

Retirement
oil on stretched canvas
8" × 10" (20cm × 25cm)

Sunrise Pumpkins
oil on canvas mounted on board
8" × 10" (20cm × 25cm)

Canvas Mounted on Board

This surface offers the texture of canvas with the solid support of plywood or Masonite. The coarse surface is good for gripping the paint for textural effects. This takes less room for storage than stretched canvas.

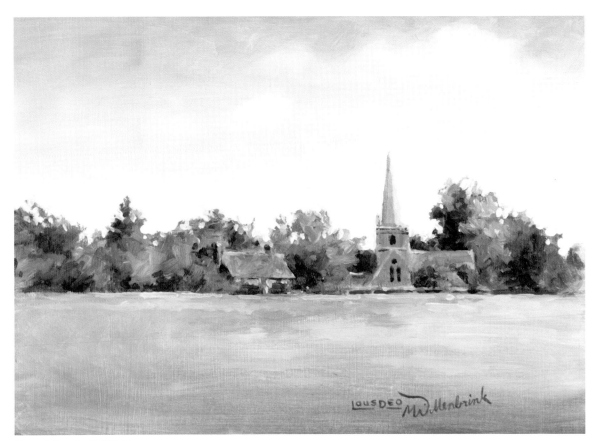

Brockham Green
oil on board
9" × 12" (23cm × 30cm)

Board Coated With Gesso

Plywood or Masonite can be coated with two or three coats of gesso and used as a painting surface. Depending on the application of gesso, the surface can be very smooth or have an assortment of textures. A smooth surface can work well for more detailed painting.

2 Basic Art **Principles**

Developing great compositions is as simple as understanding structure, value and color. With the information in this chapter, you will be on your way to composing successful oil paintings. Structural drawing will help you to understand drawing, form and linear perspective. You will learn about lights, darks and shadows and atmospheric perspective in the values section, and color relationships and temperature in the color section. Work through the mini demonstration in this chapter so that the concepts become a natural part of your painting experience. If you are working on a painting and it seems like something is just a bit off, you will probably find the solution in this chapter.

Approaching Sunset
oil on canvas mounted on board
9" × 12" (23cm × 30cm)

Structural Drawing

MINI DEMONSTRATION

Drawing involves observing a subject and visually interpreting it. Structural drawing is reducing the subject to its basic shapes without shading. Drawing is the foundation for most art, so the principles you learn through drawing can be carried over into other forms of art. The more confident you are with drawing, the more confident you will be when you paint.

Materials

Surface
drawing pad or sketchbook

Other Supplies
2B pencil, kneaded eraser

Look for the Basic Shapes
Observe the big, basic shapes, such as circles, squares and triangles, that are evident in the structure of the subject.

1 Start Big
Start by drawing the biggest, most obvious basic shapes.

2 Add the Smaller Shapes
Progressively add smaller shapes to fill in the subject.

Draw! Draw! Draw!

The simplest way to improve your drawing skills is to do it. Sketching on a regular basis, just 5–10 minutes at a time, will help you develop your drawing skills through active observation.

3 Add Details
Add the details to the basic structural shapes and develop the overall form of your subject.

Measuring and Proportioning

Using correct proportions makes your art believable. Use a pencil, brush handle or sewing gauge to observe and compare the proportions of the elements in your drawing. For more precise measurements, use a ruler or dividers when working from photo reference.

Observational Tools
Tools used for observing proportions of a subject can be as simple as a brush or a pencil. Other tools include a sewing gauge, dividers and an angle ruler, which can be used bent or straight.

Proportioning a Subject

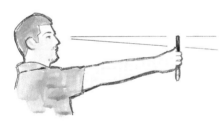

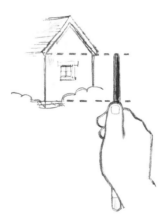

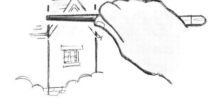

Proportioning From a Distance
When proportioning a subject from a distance, hold your arm straight out to measure the subject with a brush handle, pencil or sewing gauge, using the top of your thumb as your stopping point. Don't bend your arm at the elbow because this may affect your measurements.

1 Measure the Subject
To proportion the front of a building, observe the height with a pencil in hand, placing the top of the pencil at the top corner of the building. Move your thumb so that it lines up with the bottom of the building.

2 Compare Similar Measurements
Without moving the placement of your thumb on the pencil, reposition the pencil horizontally across the building front.

With this example, the front of the building has the same height as width. This information can be used when working out the proportions of the artwork.

Observing Aligned Elements

When drawing or painting, it is necessary to determine where the elements are in relation to each other. The placement of the elements of a subject may align them with other elements. These observations can be carried over into the execution of the artwork.

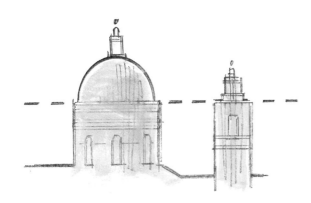

Aligned Building Features
In this sketch, the dome is aligned with part of the tower.

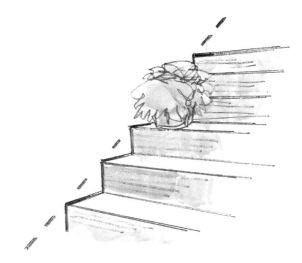

Aligned Steps
Notice how the corners of the steps are aligned.

Transferring Angles

Angles in artwork can be reproduced through observation and careful plotting.

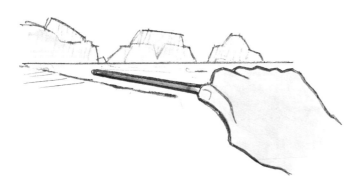

Dot to Plot
With a rigid wrist, align the tool with the angle of the subject; then, keeping it at that angle, hold it over the painting surface. Place two dots, one at the beginning and one at the end of the angle line, to plot its placement.

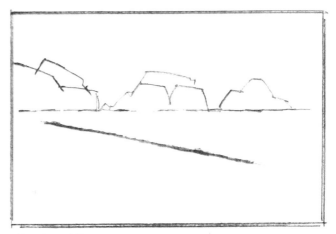

Check and Connect
To check accuracy, compare the angle of the subject to the dots on your paper. Adjust as necessary. Connect the dots to complete the angle.

Linear Perspective

Depth and distance can be implied in art through the use of perspective. *Linear perspective* uses lines and size variation of objects to make a two-dimensional image appear three-dimensional.

Inherent to linear perspective are parallel lines that converge at one or more vanishing points on the horizon line. The vantage point (where the scene appears to be viewed from) is affected by these elements and their placement in the scene.

Vanishing point placement and perspective can be challenging subjects to tackle. For in-depth instruction on these drawing principles, check out our book *Drawing for the Absolute Beginner*.

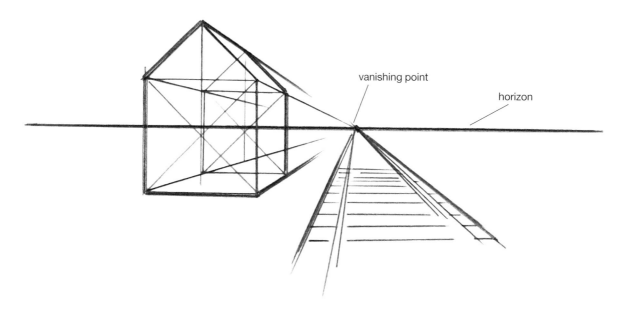

vanishing point

horizon

One-Point Perspective

As the name suggests, one-point perspective is linear perspective that uses only one vanishing point. Looking down a long, straight stretch of railroad tracks is a great way to examine one-point perspective (just stay clear of any oncoming trains!). Notice how the tracks and any lines parallel to the tracks visually converge at a vanishing point resting on the horizon. Objects of similar size appear smaller in the distance.

Gaining Perspective

Linear perspective wasn't fully understood until the Renaissance, when artists intentionally sought to comprehend it better.

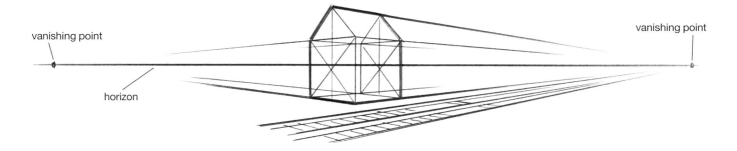

Two-Point Perspective

Perhaps more common than one-point perspective, two-point perspective uses two vanishing points and works with the same principles as one-point perspective. This scene of the corner of a building is a clear example of two-point perspective.

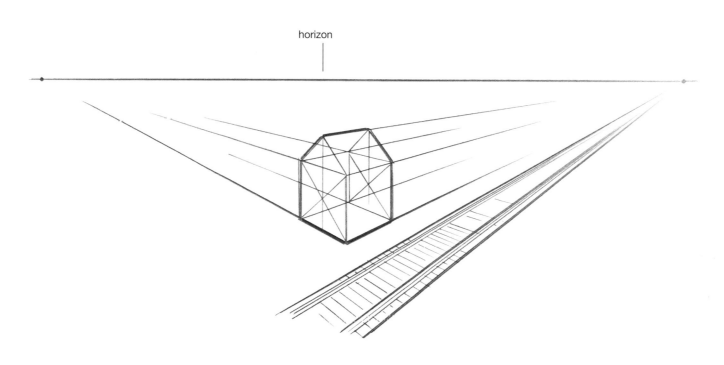

Horizon Placement

The placement of the horizon will affect the vantage point. If the horizon is placed high in the scene, the vantage point will look as if it is from above.

Vanishing Point Placement

The distance separating vanishing points can affect how close a subject appears to be in your artwork.

Value

Value is the relative lightness or darkness of a color. The lights and darks of a scene are referred to as values. Shadows, shading and the play of contrasting values make an image identifiable and give depth by expressing form.

Contrast

Value differences make *contrast*. The greater the difference in the color values, the greater the contrast.

Using Low Contrast
Using similar values creates a muted, low-contrast painting.

Using High Contrast
Using values of higher contrast adds more depth and drama to the subject.

Light Source

The placement of the light source affects the values of a scene. By changing the direction of the light source, you will change a subject's lights, darks and shadows in ways that may be subtle or dramatic.

Light Source From the Upper Left
With the light shining on the front of the building from the left, the building's shadow falls to the back right.

Light Source From Above
With the light shining from above at a slight angle, the building creates a small shadow.

Light Source From Behind, on the Right
Shining from the sky above the building on the right, the light source creates a shadow coming forward and darkening the walls of the building.

Atmospheric Perspective

Atmospheric perspective (also referred to as *aerial perspective*) implies depth by means of differing values. As elements are more distant, they become muted in value and less defined. The color of the distant objects may become more bluish gray.

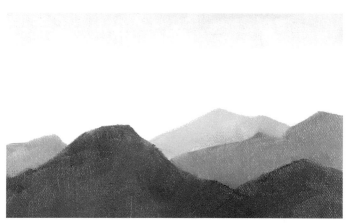

Fading Into the Distance
Depth can be enhanced by use of atmospheric perspective. The use of values causes the mountains to seem to fade into the distance.

Rods and Cones

Our eyes have over 100 million light-sensitive cells, designated as rods and cones. Rods are more abundant and they register lights and darks to distinguish form and shape. Cones comprehend color (red, blue and green) and sharp details.

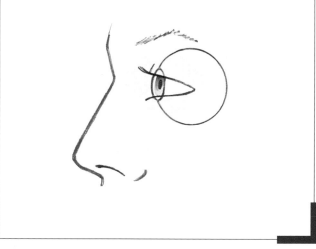

Using a Value Scale

A value scale is a tool that shows a range of values, from light to dark. It is used during painting to compare the values of a scene to those of the painting. You can buy a value scale or make your own by painting different values of a dark color on a piece of primed cardboard or canvas and trimming it to size. The holes punched through the scale allow you to isolate, identify and match the value of the subject with the value of the painting.

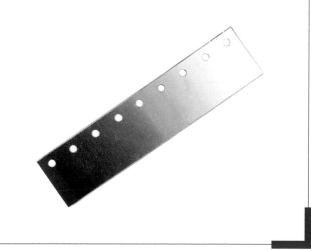

Color Basics

Choosing and mixing the right colors for your paintings is easy once you have simple tools to work with such as a color wheel.

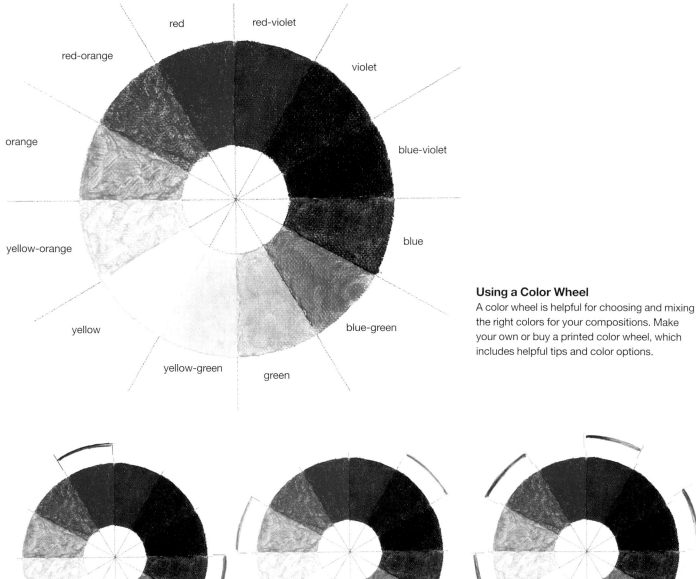

Using a Color Wheel

A color wheel is helpful for choosing and mixing the right colors for your compositions. Make your own or buy a printed color wheel, which includes helpful tips and color options.

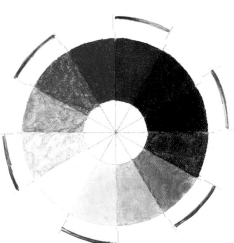

Primary Colors

Of the colors we perceive, the basic colors are red, yellow and blue. All other colors are made from these three primary colors. The colors I used in making this color wheel are Lemon Yellow, Permanent Rose and Phthalo Blue (Red Shade).

Secondary Colors

Combining two primary colors creates a secondary color. Orange, purple and green are the three secondary colors.

Tertiary Colors

Combining a primary color with an adjacent secondary color creates a tertiary color.

Complementary colors are colors that are directly opposite each other on the color wheel. Mixing any combination of complementary colors will create a neutral gray-brown color.

Analogous colors are a group of colors that are near each other on the color wheel. Because they are all similar in origin, they will keep their bright, pure appearance when used together.

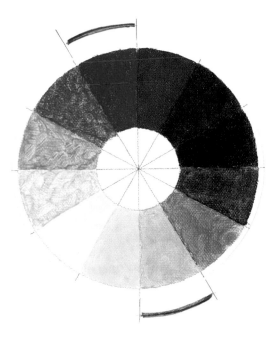

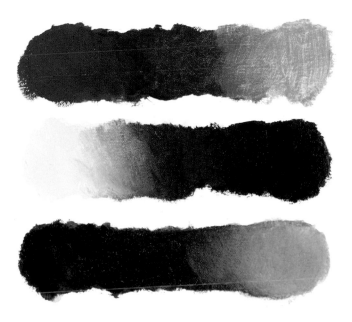

Complementary Colors
Any two colors that are directly opposite each other on the color wheel are complementary. Notice that any two complementary colors are derived from all three primary colors.

Combining Complementary Colors
Combining complementary colors results in neutral colors. If you are in a painting session and you want to make one of your colors muted, just add a little of its complement.

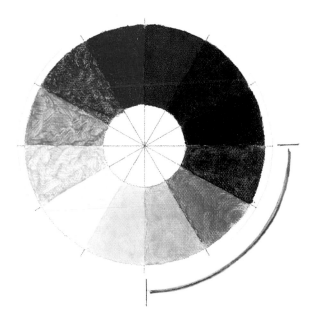

Red, Blue and Green
While red, blue and yellow are the three primary colors of reflected surfaces, such as paintings and print material, red, blue and green are the primary colors in light, such as found when light is refracted by a prism.

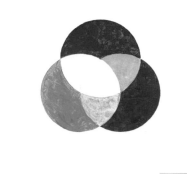

Analogous Colors
A group of analogous colors makes up about a quarter of a color wheel.

Colors can be thought of as warm or cool. Yellows, oranges and reds are warm colors, while greens, blues and purples are cool colors.

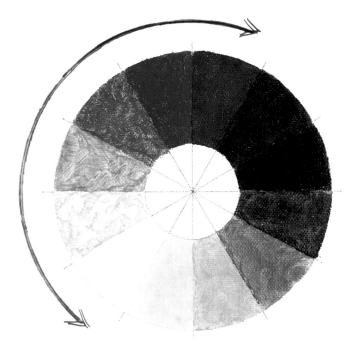

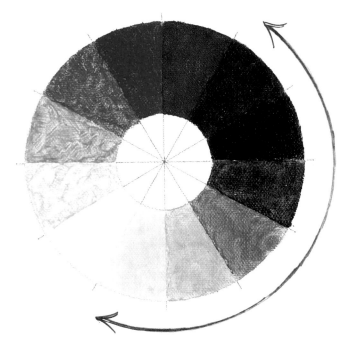

Warm Colors Advance
Yellow, orange and red objects tend to appear as if they are coming forward.

Cool Colors Recede
Green, blue and purple objects tend to appear as if they are receding.

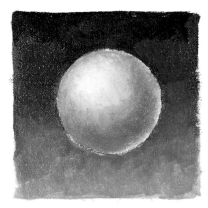

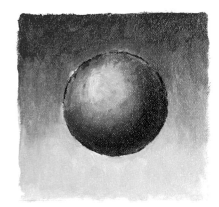

Creating Depth by Using Color Temperature
Warm and cool colors can be used to enhance depth in a scene. The orange ball in the painting on the far left appears to come forward from the background, while the painting on the near left makes the placement of the ball harder to comprehend. The blue ball appears smaller in a background that is bright and advancing.

Color Intensity

Intensity, also referred to as *saturation*, is the potency of a color. Color in its purest form, without white, black or any other color added to it, has the greatest intensity. Color intensity is different from value, which considers how light or dark a color is.

Different Intensities, Similar Values
Some colors, such as yellow, can vary in intensity but remain similar in value.

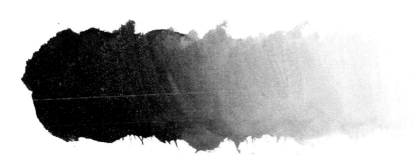

Different Intensities, Different Values
Other colors, such as purple, can change in both intensity and value.

Glowing Results

With the strategic use of color intensity, value and temperature, you can create a warm, glowing feeling in your paintings. Notice how the warm colors surrounded by cool colors, make the window appear to glow.

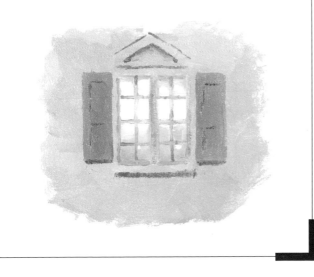

Combined Perspective

Linear and atmospheric perspective along with color temperature can be combined to convey depth. Before reading further, see if you can pick out and identify elements that contribute to linear perspective, atmospheric perspective and color temperature in this painting.

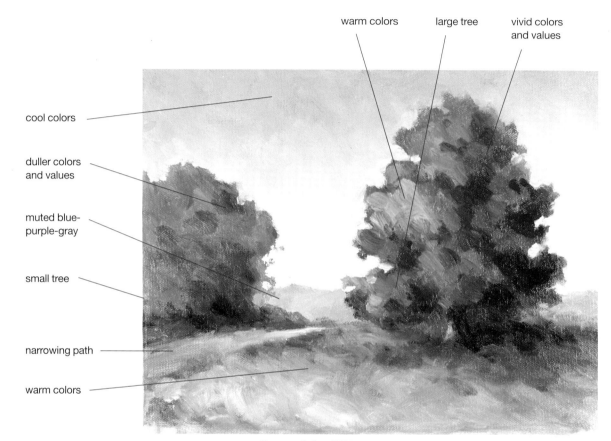

warm colors large tree vivid colors and values

cool colors

duller colors and values

muted blue-purple-gray

small tree

narrowing path

warm colors

Recognizing Different Aspects of Perspective

Paintings generally combine multiple techniques to indicate depth. The following is a breakdown of the separate elements that create depth in this painting.

- **Linear perspective:** A key aspect of linear perspective is that closer elements in a scene appear larger than elements that are farther away. The tree on the right is closer and appears larger than the more distant trees on the left. The path also narrows as it goes farther into the picture plane.

- **Atmospheric perspective:** The use of atmospheric perspective is evident in the brighter, more vivid colors and values in the foreground. As the elements recede into the background, they become duller. Notice how the tree on the right is brighter than the trees on the left and that the distant hills are a muted blue-purple-gray.

- **Color temperature:** Warm colors in the foreground and cool colors in the background help express depth. The tree on the right, predominantly warm in color, rests in front of an expanse of cool blue sky.

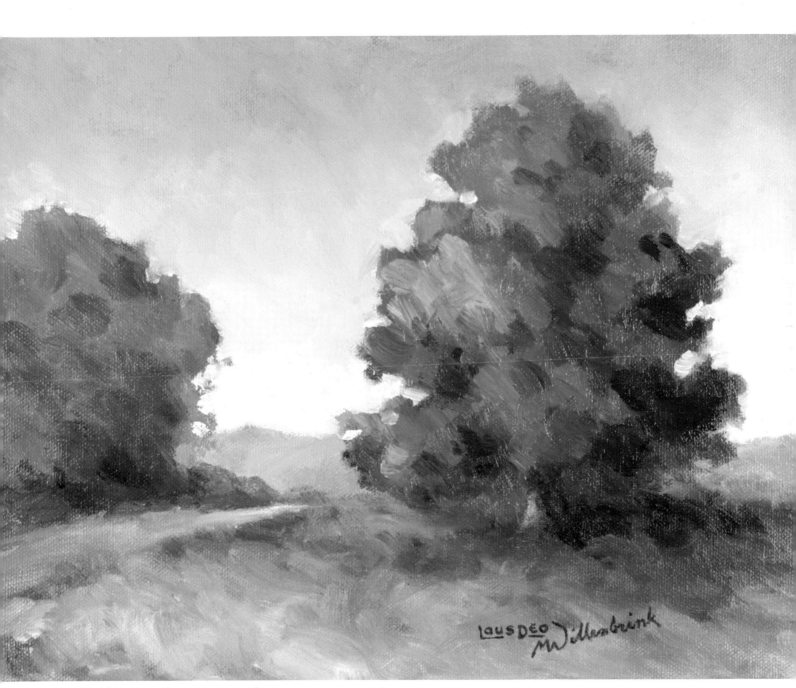

Autumn Landscape
oil on canvas mounted on board
8" × 10" (20cm × 25cm)

Composition

Composition is the arrangement of elements in a work of art. It involves using design elements, such as lines, shapes, values and colors. A painting with a good composition is one that communicates its intended message to the viewer. Here are some tips for successful compositions.

Evens and Odds

The number of elements can affect the balance and movement of a scene. An even number of elements usually isn't as interesting as an odd number.

Evens Are Repetitive
An even number of elements can seem dull and predictable.

Odds Add Interest
An odd number of elements can make the scene more interesting.

Even to the Edges
This principle also applies to the number of elements reaching the edge of your paper. Similar elements reaching two edges may not look bad, but the overall composition could be better.

Odd to the Edges
Here, the trees reach three edges, giving the composition a more interesting appearance.

Symmetrical and Asymmetrical

Though a symmetrical composition can be orderly, it may also look mechanical and bland. An asymmetrical composition can give a more random, yet balanced feel.

Symmetrical and Static
Though evenly balanced, a symmetrical composition can be boring.

Asymmetrical and Natural
The dominant and subordinate elements balance each other for a more natural feel.

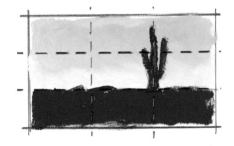

Thinking in Thirds
Use a grid to divide the picture into thirds, then place the elements along the grid lines. This is called the *rule of thirds* and results in compositions that are pleasing to the eye.

Leading the Eye

Movement is an important part of composition and keeps the viewer engaged.

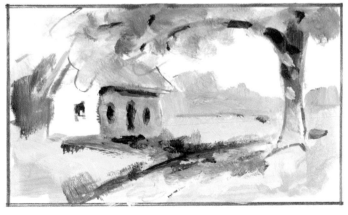

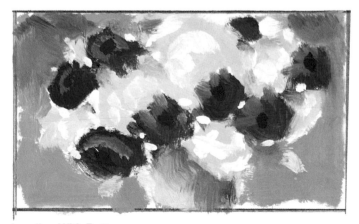

Leading With Line
One way to lead the viewer is with lines and other elements, pointing out where the eye should look next in the painting. Notice how the path, tree, house and shadows direct the eye through the scene.

Leading With Pattern
A more subtle way to direct the eye is to alternate elements, creating movement through pattern. In this example, the red flowers act as stepping stones to lead the viewer.

Moody Formats

The shape of the picture area can influence the overall feel of a composition.

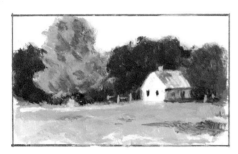

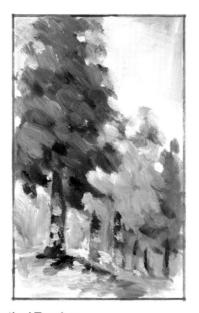

Horizontal Calm
Stable and serene, horizontal formats lend themselves to pastoral scenes.

Vertical Tension
An intense, powerful subject may be best stated through a vertical format.

Don't Be Square
A composition with a square format can be predictably boring.

Cropping a Subject

It is necessary to determine the picture area by cropping the subject. This is especially true when painting outdoors (en plein air).

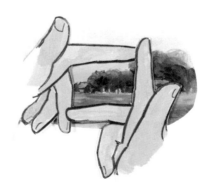

Using a Viewfinder
Viewfinders can be bought, ready for use, or make your own by cutting a window out of a scrap of cardboard. The window size should be proportional to your painting surface.

Viewing Through Your Fingers
If you don't have a viewfinder, use your fingers to form the shape of a rectangle (or the shape of your painting surface).

Tip
A composition doesn't have to be complex to be complete. A simple composition can often state a message better than one cluttered with irrelevant elements.

The Trouble With Tangents

Tangents occur where two or more elements come together. Try to avoid making them as they can confuse the viewer and create an unwanted distraction.

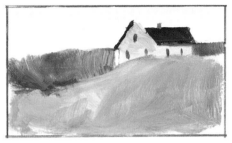

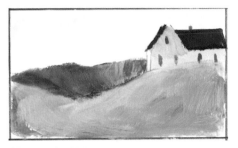

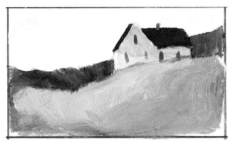

Too Many Lines Lining Up
The roof edge of the building lining up with the distant hills creates unnecessary tangents.

Life on the Edge
Distraction is created by placing the end of the building at the right edge of the picture.

Remedy for the Tangents
By repositioning the building, the scene is free of the tangents and the subject has more clarity.

Being Led Astray

The placement and direction of the elements may unintentionally guide the viewer right out of the scene.

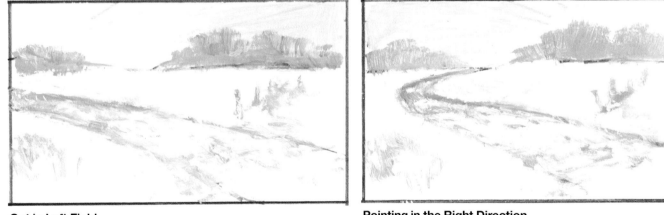

Out in Left Field
In this example, the direction of the path along with the light of the sky points the viewer outside the picture, to the left.

Pointing in the Right Direction
Simple adjustments to the path and sky keep the viewer within the scene.

Structure, value, color and composition work together to create different moods. Compare the two paintings on these pages. *Italian Holiday*'s vertical format emphasizes the magnificent archway that dominates the scene. The horizontal format of *California Surf* draws attention to the motion of the waves.

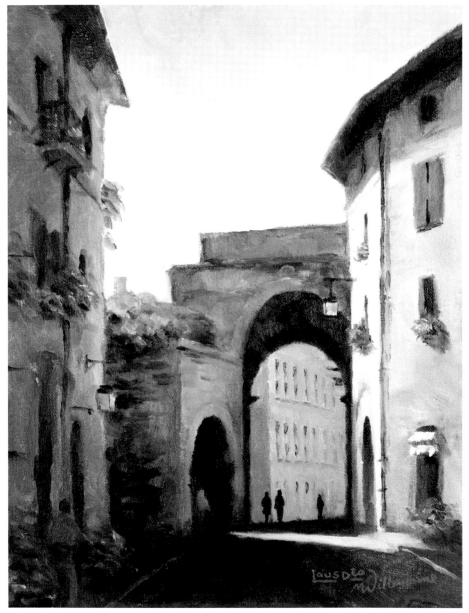

Italian Holiday
oil on canvas mounted on board
12" × 9" (30cm × 23cm)

Linear Perspective

This painting draws you into the scene so that you feel as if you were walking down this Italian side street. Notice the lines of the buildings. They point into the center of the scene, creating a strong linear perspective. The foreground buildings and elements are larger, while elements receding into the background become smaller.

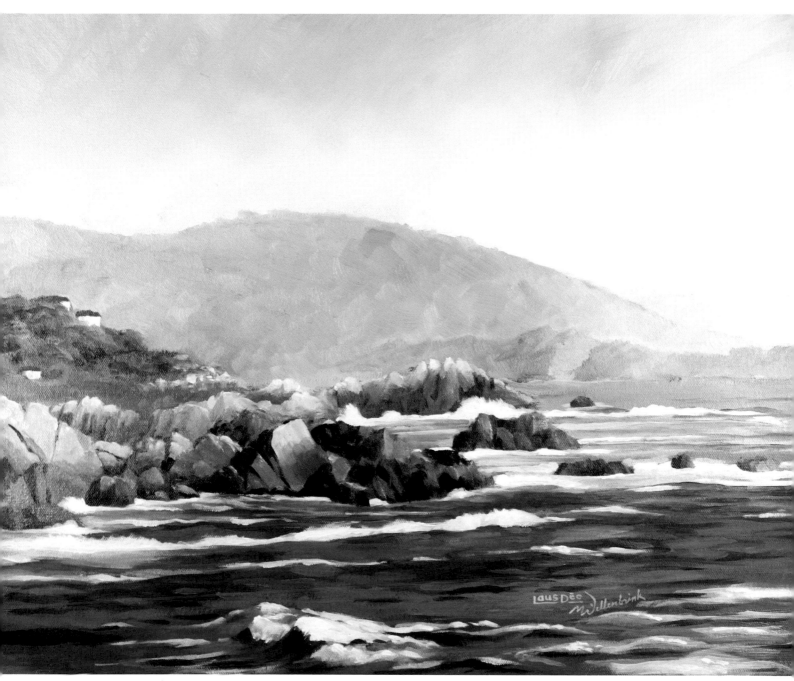

Atmospheric Perspective

This painting makes you feel as if you could see and hear the waves crashing on the surf. Atmospheric perspective allowed me to give this painting a depth that gives you the sense that you right there. The rocks and ocean waves of the foreground are painted in detail, while the back-ground rocks, water and mountains are muted. I used rich, bold colors for the foreground rocks and water and muted colors for the background water and distant hills.

California Surf
oil on stretched canvas
16" × 20" (41cm × 51cm)

3 Practicing the **Techniques**

Now that you know about materials and basic principles, it's time to have some fun learning about and practicing oil painting techniques. It's important to understand these techniques and the results they produce. Once you become comfortable with these different painting techniques, it will be easy to choose techniques that will create the desired effects. For example, the fast-paced nature of *alla prima* painting is well suited to painting en plein air, while glazes are more appropriate for painting a detailed portrait. Keep your supplies handy so that you can actively participate in this chapter.

Smoke and Shadows
oil on stretched canvas
5" × 7" (13cm × 18cm)

Mixing Paint

Mixing the paint is one of the joys of oil painting. For the best results, use the correct colors and mix enough paint for the size of your painting. In general, make sure the paint is blended thoroughly on the palette. However, sometimes you may want to blend the paints on the painting surface rather than on the palette. Mixing is fun and easy once you learn some of these simple suggestions.

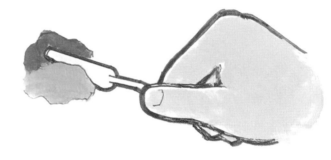

Add Dark to Light

Dark colors are more dominant than light colors. When mixing paint, start with the lighter color then add small amounts of the darker color. If you try to do the reverse, you may have to mix more paint than you need to get the color you want. Similarly, when placing paints on your palette, add pea-size amounts of the dark colors and be a bit more generous with the light colors. You can always add more paint as you go, but it's hard to keep oil paints fresh once they have been placed on the palette.

Mixing With a Palette Knife

Though it is common to use the brush that you are painting with to mix paint, a palette knife is also useful for mixing paint. Try mixing some paint with a brush, then switch to a palette knife. With the knife, you can scoop freely without clogging or damaging your brush.

Keep It Clean

When using thinner or medium, avoid dragging the brush against the lip of the palette cup so the paint doesn't release from the brush into the cup and dirty the thinner or medium.

Loading a Brush

How much paint do you want on your brush? The amount of paint you load on a brush depends on how you plan to apply the paint. *Push loading* and *pull loading* are two ways to load a brush. Use the push loading method if you want to grab a lot of paint onto your brush for applying a thick layer of paint. Use the pull loading method to load a smaller amount of paint onto your brush.

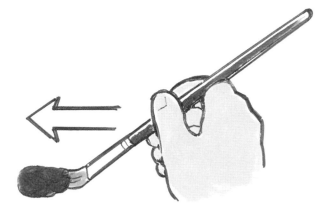

Push Loading
This method involves pushing the brush into the paint. Pushing the brush is hard on the hairs. For this reason, flat and filbert bristle brushes work best for the push loading method. If you push a round brush into your paint, it will splay the bristles, ruining its nice tip.

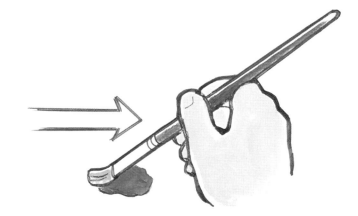

Pull Loading
This method requires pulling the brush into a quantity of paint on the palette. The angle of the brush determines how much paint is put onto the brush.

Avoid Overloading the Brush
Paint brushes work best when they are not overloaded with paint. Overloading makes the paint harder to control, and paint worked into the ferrule can damage the brush. If the brush becomes choked with paint, wipe it clean (see page 47).

A Little Dab'll Do Ya!
If you want just a bit of paint on the tip of your brush, use the push loading method to jab the tip of your brush into your paint.

Cleaning Brushes

Thorough cleaning is essential for maintaining brushes. Proper care of brushes ensures that you get the most use out of them. Be gentle with fine hair and round brushes while using or cleaning them.

The Gentle Touch
Be careful with your brushes. If the hairs are splayed too much, they can become permanently damaged and never return to their intended shape.

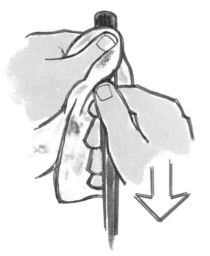

1 Wipe It Off
To remove paint from a brush, wrap it with a paper towel or rag, then squeeze the bristles with one hand and pull the brush through the towel with the other hand.

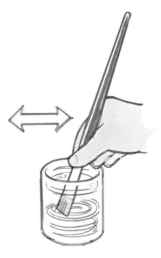

2 Clean in a Brush Wash
Swish the brush back and forth in a brush wash. If necessary, drag the brush along the screen or coil to remove paint from the brush.

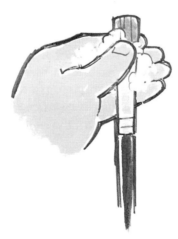

3 Clean With Soap and Water
One of the best benefits of using water-soluble paints is that brushes can be cleaned with just soap and water. Brush soap or cleaner comes in liquid, gel or bar form. After your brush is clean, many of these special soaps can be left lathered on your brush to shape and condition the bristles. Just follow the manufacturer's instructions. After cleaning, reshape the brush hairs and let dry.

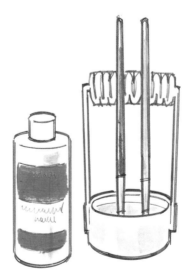

4 Soak If Needed
Soak brushes gummed up with old paint in a brush cleaner. Just follow the manufacturer's directions, then clean the brushes with soap and water, reshape their bristles and let dry.

Painting Techniques

During the painting process, any combination of techniques can be used to apply the paint. Though there are many different ways to paint the same subject, through experience you will discover the techniques that you enjoy most for achieving the look that you like. The more you paint, the more comfortable you will be when you do it. Here are some basic techniques to explore.

Fat Over Lean

To allow proper adhesion and to prevent cracking and flaking, apply paint with more oil or "fat" over leaner, less oily paint. This is especially important if the paint is drying between layers. If you are going to work on the same painting for more than one session, add a little medium or oil to the paint.

Thick Over Thin

Start with thinner layers of paint and work gradually toward thicker layers. Working this way allows the initial layers to dry before the subsequent layers. This is especially important when working in multiple painting sessions or if the paint has dried between layers because it helps prevent the paint from cracking over time. If you add a layer of thin paint over a thick layer of previously applied and dried paint, your painting is liable to crack.

Wash
A wash is a transparent application of paint that has been diluted with water or thinner. Commonly used to lay a ground, this technique can be used singularly or with other techniques.

Glazing
Glazing involves applying thin, fluid paint over dry layers. This technique can achieve finely detailed results, but the drying time necessary for multiple layers can be a problem.

Drying Times

Drying time can vary with each paint color, so research the manufacturer's information and take this into consideration when painting with methods that involve drying time between layers of paint.

Scumbling

This technique involves brushing undiluted paint over dry paint. Some of the dry paint's color and texture will show through the newly applied paint. The difference between glazing and scumbling is that with scumbling the paint is undiluted.

Impasto

Italian for "paste" or "dough," impasto refers to thick applications of paint. This method of painting can use much more paint than other methods, such as glazing.

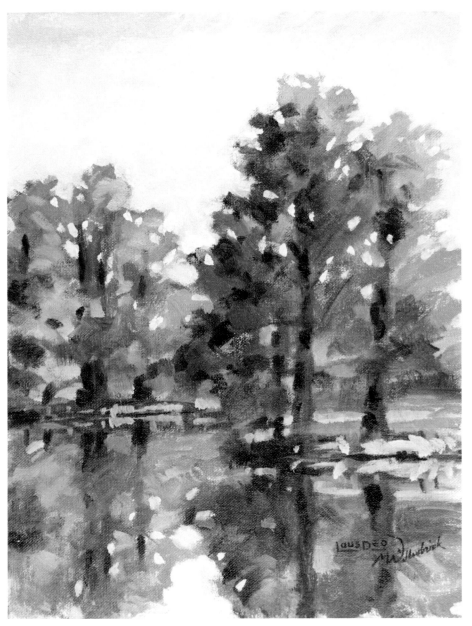

Alla Prima

This technique derives its name from the Italian, meaning "at first." To use this method, quickly paint the painting, in general, as it will appear when it is completed. After laying down the structure and colors, add details to complete it. Quick, single-session plein air paintings are often completed in this manner.

Direct or Indirect?

Quick, single application painting techniques, such as *alla prima*, are considered *direct painting*, whereas techniques that require multiple layers, such as glazing, are termed *indirect painting*.

Trees and Reflections
oil on canvas on board
12" × 9" (30cm × 23cm)

Wet-Into-Wet Painting

MINI DEMONSTRATION

With this exercise you will learn how to paint wet-into-wet. It starts with the paint surface covered with wet paint, and then wet paint is added and blended. For an inexpensive practice surface, try painting on a small sheet of canvas pad taped on all four sides to board mounted on your easel. Experiment with different colors and different sizes of flat or filbert brushes as you try these exercises.

Materials

Surface
5" × 8" (13cm × 20cm) canvas

Paints
Magenta, Yellow Ochre

Brushes
no. 8 or ½-inch (12mm) flat
no. 12 or 1-inch (25mm) flat

Other Supplies
palette, palette knife, rags or paper towels, easel, smock or apron, water, brush wash

1 Lay Down the Base Color
Paint a base color of Yellow Ochre over the painting surface with a no. 12 flat.

2 Place the Second Color Over the Base Color
With a no. 8 flat, paint Magenta at the top over the wet base color. Do not begin blending yet.

3 Start Brushing the Second Color Into the First Color
Brush the previously applied Magenta over the Yellow Ochre with crisscross strokes, starting at the top corner and working one row across.

4 Continue Brushing the Second Color Into the First Color
Repeat the previous step, moving down and working the next row across. Repeat with as many rows as necessary to accomplish the desired blend. Don't be tempted to go back or jump ahead in the process, as this will interrupt the smooth transitional look.

5 Brush Over for A Smoother Blend
Brush with crisscross strokes, starting at the beginning and continuing over the sections already worked to blend the colors more evenly.

6 Additional Blending
For a smoother finish, start at a top corner with a clean brush and pull it all the way across the canvas. Move down and work the next row across from the opposite direction. Continue back and forth in this manner, working down row by row. Repeat this process so that the colors blend seamlessly into each other.

52

Wet-Into-Dry Painting

MINI DEMONSTRATION

This method is similar to painting wet-into-wet, except that the base color is dry, so the paint mixing characteristics are different. You can apply a thin base color or even use a wash if you want it to dry more quickly.

Materials

Surface
5" × 8" (13cm × 20cm) canvas

Paints
Dioxazine Purple, Magenta

Brushes
no. 8 or ½-inch (12mm) flat
no. 12 or 1-inch (25mm) flat

Other Supplies
palette, brush wash, palette knife, rags or paper towels, easel, smock or apron

1 Lay Down a Base Color
Paint a base color of Magenta over the painting surface with a no. 12 flat and allow the paint to dry.

2 Place the Second Color Over the Dry Base Color
Paint Dioxazine Purple over the Magenta with a no. 8 flat. Do not start blending yet.

3 Start Brushing the Second Color Over the First Color
With crisscross strokes, start at a top corner and work one row across, brushing the Dioxazine Purple over the Magenta. The Dioxazine Purple will gradually become thinner, allowing the Magenta to show through.

4 Continue Brushing the Second Color Over the First Color
Repeat the previous step by moving down and working one row across, then the next row and so on. Repeat as necessary. Do not go back or jump ahead in the process, as this will interrupt the smooth transitional look.

5 Additional Blending If Needed
For a smoother appearance, start at the top corner with a clean brush and pull the brush across the surface. Move down and pull the brush in the opposite direction. Continue working down row by row until completed. You can repeat this process if you want the colors to blend seamlessly into each other.

Painting With a Palette Knife

Some artists enjoy the unique results and thick textural effects they can create by painting with palette knives. Use palette knives to complete an entire painting, or use them to accent or aid in the process of painting, such as to smooth out or remove a heavy buildup of paint.

Spreading Paint
Scoop paint onto the underside of the knife, then squish the paint onto the painting surface and spread.

Scraping Paint
Use the knife to move or thin paint from one region of the surface to a different region. Place the back of the knife edge perpendicular to the painting surface and pull it through the paint.

Lifting Paint
To lift paint, place the front edge of the palette knife on the painting surface and pull it under the paint, scooping it onto the knife.

Laying or Removing Lines of Paint
Deposit or remove paint by placing the edge perpendicular against the paint surface and pulling sideways. Scraping the knife tip up and down is a common technique for indicating grass.

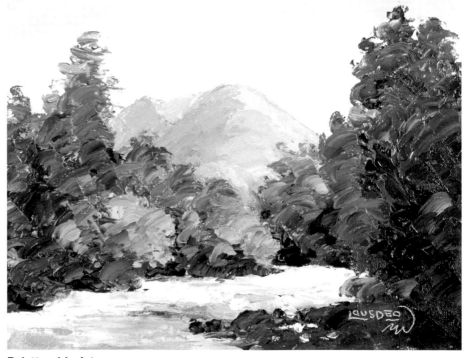

Palette-able Art
Palette knife painting can bring out your creativity. Try experimenting with different palette knives for different results.

Lifting and Wiping off Paint

Oil painting is changeable. During the painting process, you may want to remove or change a small spot or an entire region of wet paint. Knowing how to lift and wipe off paint is especially useful for washes, glazes and underpainting.

Using a Rag or Paper Towel

Simply wipe up the excess paint with a flattened rag or paper towel. Use a lint-free rag or paper towel to avoid leaving unwanted fibers. Twist the rag or paper towel to make a smaller end to lift paint from a small space.

Using a Flat Brush

Especially good when working with washes, flat brushes can be used to chisel away or lift unwanted paint.

Putting Your Credit Card to Good Use

You can also use a credit card, rag or paper towel to spread or remove paint.

When You Need a Lift

Lifting paint is part of the painting process, and lifted areas can become part of the finished painting.

Positive and Negative Painting

MINI DEMONSTRATION

Positive and negative painting refers to the direct or indirect way the forms are made on the painting surface. Positive painting is the more common form of painting. While negative painting is not as common, many artists use this approach to work around a subject already painted or to create a painting with a unique twist in its presentation.

Materials

Surface
canvas pad cut into 6" × 4" (15cm × 10cm) sheets

Paints
Sap Green, Titanium White, Ultramarine Blue

Brushes
no. 8 or ½-inch (12mm) flat
no. 2 or ¼-inch (6mm) filbert
no. 4 or $^5/_{16}$-inch (8mm) filbert

Other Supplies
thinner, brush wash with water

Painting Positive Forms

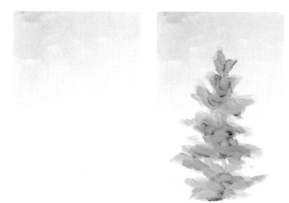

1 Start With the Background
Paint the background with a no. 8 flat and a mix of Titanium White and Ultramarine Blue.

2 Paint the Subject
Paint the positive image of the subject on the background using Sap Green and a no. 4 filbert.

Painting Negative Forms

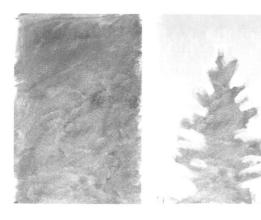

1 Start With the Color of the Subject
Paint Sap Green over all of the painting surface using a no. 8 flat.

2 Paint the Background
Add the background color with a mix of Titanium White and Ultramarine Blue, painting around and forming the shape of the subject with a no. 8 flat. Use a no. 4 filbert for more detailed areas around the tree.

Combining Positive and Negative

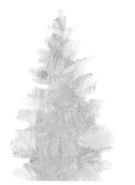

1 Start With the Background
Paint the background with a mix of Titanium White and Ultramarine Blue and a no. 8 flat.

2 Paint the Subject
Paint the positive image of the subject with Sap Green on the background, using limited details and a no. 4 filbert.

3 Add Details
Define the form by adding the background mix of Titanium White and Ultramarine Blue over the form using a no. 2 filbert.

Hard and Soft Edges

Forms can be painted with hard or soft edges that influence how defined they are. Hard edges define a form distinctly and can give an impressive or clear viewpoint. Soft edges may give a more romantic feel to a floral arrangement or a misty feel to a landscape. Using both hard and soft edges strategically can create the impression of depth.

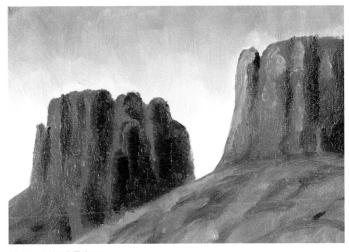

Using Hard Edges
Forms with hard edges are sharply defined. As you paint, keep the colors separate to create hard edges.

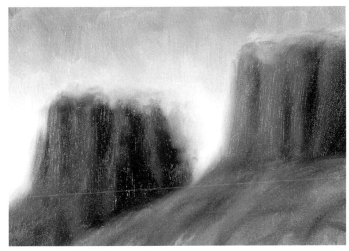

Using Soft Edges
Forms with soft edges are less defined and blend with their surroundings. Make soft edges by very lightly brushing the paint while it is still wet.

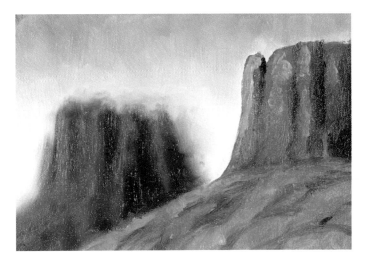

Using Hard and Soft Edges Together
Use hard and soft edges in the same painting to emphasize depth and to direct the focal point. The hard edges of the mountain on the right catch your eye, and the close-up details tell your brain it's closer than the mountain on the left. The soft edges and lack of detail on the mountain on the left imply that it's farther away.

Discussing Plein Air Painting

Plein air refers to painting outdoors. There's nothing wrong with working from a still life or photo, but you can't replace the experience that comes from studying landscapes with the natural light of the sun playing with the highlights, shadows and colors of your setting.

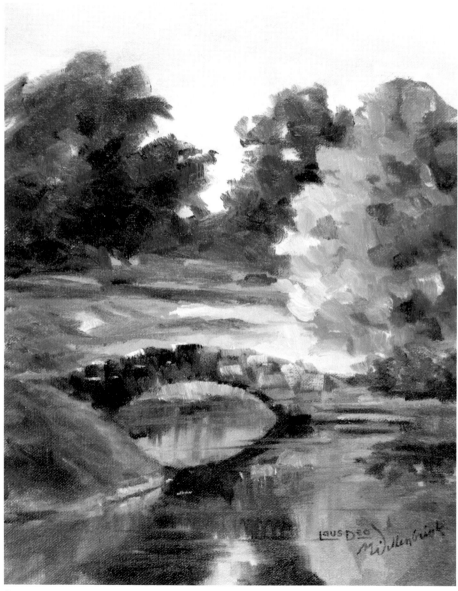

Landscape With Stone Bridge
oil on canvas mounted on board
12" × 9" (30cm × 23cm)

Capturing the Moment

When painting en plein air, it is essential to work quickly to capture the scene without too many changes. You can see that I didn't work on detail in this scene, but instead used quick, loose brushstrokes to capture the experience.

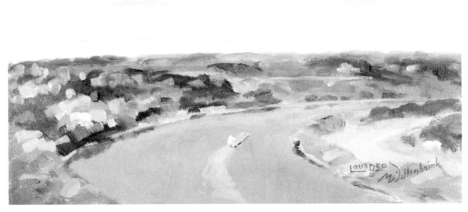

River Bend
oil on canvas mounted on board
9" × 12" (23cm × 30cm)

Ever Changing

Capturing a constantly changing landscape can be a challenge. When I painted this scene the sky changed, the sun moved, shadows shifted, light areas changed and the barge slowly moved up the river. First I did a quick underdrawing of the river and horizon, then I placed the large groupings of colors, after which I started to blend colors and add more detailed brushstrokes. This painting took about two hours to complete.

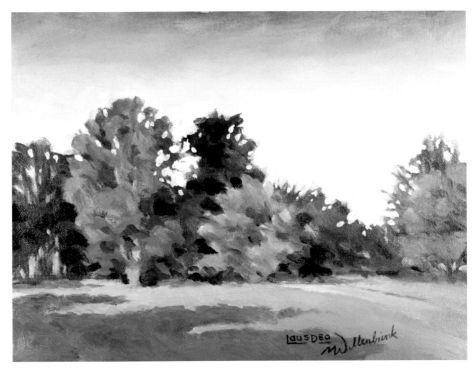

Study of Trees
oil on canvas mounted on board
8" × 10" (20cm × 25cm)

Complementary Contrast

This is a plein air study of trees that I did one afternoon. I used red (the complementary color to green) to paint an underpainting of the trees. Then, as I added different colors of green, I let some of the red show or blend with the paints for a nice contrast and variation.

4 Let's **Paint!**

It's time to put what you have gleaned from the first three chapters of this book into practice. Enjoy the creative process and expect to be pleasantly surprised by the success you have with each finished painting. Each demonstration has its own materials list. Your studio should be set up by now, but make sure you have the suggested materials before you begin. In each demonstration we've also listed the art principles and painting techniques taught in other parts of this book. You may want to refer to these before and during your painting session.

If your family and friends are like ours, they are excited about the artwork you are completing and would love to see photos of your paintings. Consider sending digital images or making note cards to send to your favorite people.

It's All Good
Every painting you complete may not be a masterpiece, but every time you paint can be a learning experience.

Proud Enough to Show It
Mary painted *Summer's End* while taking my Oil Painting for the Absolute Beginner class. As an absolute beginner, Mary likes demonstrations that promise the most encouraging and rewarding results.

Summer's End
Mary Willenbrink
oil on Masonite
12" × 9" (30cm × 23cm)

Getting Ready

Painting is a special experience because each person is unique, and your own personality and style will show through your paintings. I am always amazed that a class of students painting the same subject, using the same techniques, will yield wildly different results, with every painting expressing the unique style of the artist. Cultivate your talent and experience so that you can express your unique creativity through your art.

We want you to be as successful as possible while using this book. Here are a few more tips before you get started.

Start Simple

If painting big feels overwhelming, start with smaller paintings. Also start with a simple subject and composition. We have laid out this book so that the easier demonstrations are at the beginning and the more challenging ones are at the end.

Pace Yourself

Some of the complex, detailed paintings that we admire in museums took years to complete. Others were done quickly, in one painting session. Go at a pace that is comfortable for you with the understanding that the pace you choose will also influence your end results. For paintings that require more than one session, list the colors in each mixture along with a swatch of the mixture. This will be a useful reference for the completion of that painting.

Date Your Paintings

Gauge your progress by writing the completion date on the back of each painting. As time goes by, take out your paintings and examine your growth. After setting aside a painting for a while, you may be able to view it more objectively and with new appreciation.

Mirror, Mirror
Staring at a painting from the same distance and viewpoint can cloud your perception of your painting. Step back from your easel now and then to help you discern the progress of your painting. Another way to detach yourself and observe the colors and composition of your painting more objectively is to look at your art through the reflection in a mirror.

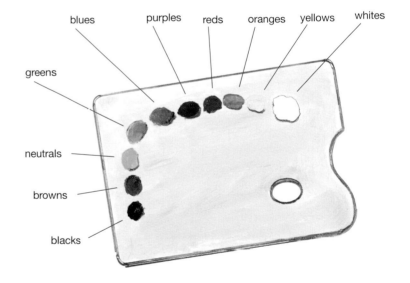

Orderly Paint Placement
When placing the paints on the palette, consider putting them in an order similar to the arrangement of the color wheel, with white at the end, next to yellow. With this setup, the colors graduate in an orderly and familiar manner, leaving room for mixing the paint in the center. The space at the top can be used for mixture swatches so that you can compare these mixtures to the colors you are trying to match.

Using a Ground

A *ground* is a thinned wash of paint put down as a base color for a painting. Grounds provide tone and color so that you don't have to start with a stark white painting surface. Grounds can be painted on with a brush or smeared on with a rag.

Burnt Sienna Burnt Umber Yellow Ochre Payne's Gray

Common Grounds
Browns and neutral colors are commonly used as grounds, but any color can be used.

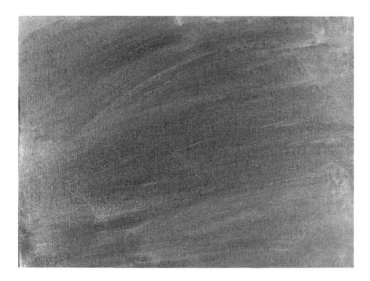

Wet and Dry Grounds
You can let a ground dry before painting over it, or try painting into it while it's still wet. Water-soluble oils work well for dry grounds because they dry quickly. Water-soluble oils dry faster than traditional oils but slower than acrylics.

Using Complementary Colors

Colors that are complementary to the dominant color of your painting subject can be used as ground colors. For example, a painting of green trees may start with a ground color of red. This technique will make the dominant color seem less overwhelming and easier to vary.

Underdrawing and Underpainting

Underdrawings and underpaintings are like road maps that help you plan a painting before adding the finished painting layers. To create an underdrawing, draw the basic structure of the subject on a dry painting surface with pencil, charcoal or paint. An underpainting goes beyond the basic structure, developing the lights and darks. Erase or wipe away to make adjustments. For pencil or charcoal, spray your drawing with a fixative before painting to keep the graphite or charcoal from smearing into and dirtying your paint.

Using an Underdrawing
Underdrawing can be used with or without a ground. The great thing about an underdrawing is that it can be wiped off or erased away until you have a satisfactory structure for the foundation of the painting.

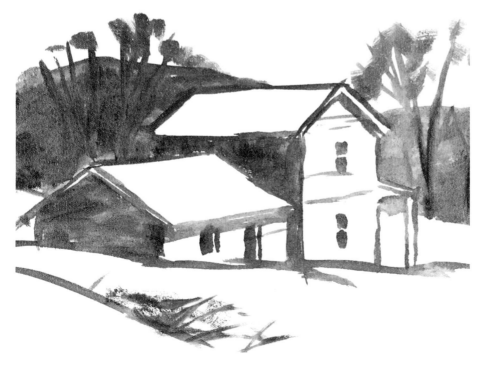

Using an Underpainting
Similar to an underdrawing, an underpainting involves painting the basic structure and dark areas of the subject with a dark color. Apply the paint thinly so it can be wiped away easily for corrections and so that it dries quickly. Underpainting can be used with or without a ground. If underpainting is used over a wet ground, light areas can be made by lifting or wiping away the ground color to expose the lighter painting surface.

You can let an underpainting dry before painting over it, or try painting over it while it is still wet. If you apply paint to a wet underpainting, expect the underpainting to mingle with and darken the newly applied colors.

63

Monochromatic Rocks

MINI DEMONSTRATION

Monochromatic painting offers an exceptional opportunity to focus on values and painting techniques. By developing a range of lights and darks, you will see that a painting can be complete without relying on color.

Keep in Mind

The light source for this scene is coming from the upper left. This makes the rocks generally appear lightest at their upper left and darkest toward the lower right.

1 Apply a Ground
Use a rag to apply diluted Payne's Gray over the painting surface to create a light, transparent ground. Don't worry about making the ground completely even since you will paint over it.

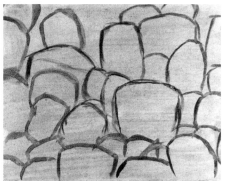

2 Paint the Underdrawing
Using a no. 2 filbert, draw the shape of the rocks with Payne's Gray. Start with the big central rocks and work out.

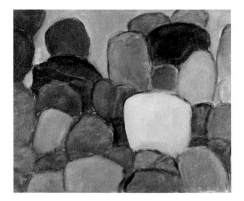

3 Begin Painting the Rocks
With mixtures of Titanium White and Payne's Gray, begin filling in each rock with its general value using a no. 8 filbert. Adjust the values by lightening some rocks and darkening others to enhance the composition.

Materials

Surface
8" × 10" (20cm × 25cm) canvas on board

Paints
Payne's Gray, Titanium White

Brushes
no. 8 or ½-inch (12mm) filbert
no. 2 or ¼-inch (6mm) filbert
no. 4 rigger

Other Supplies
palette, brush wash with water, palette knife, rag or paper towel, easel

Optional Supplies
thinner, medium, palette cups, mahlstick, smock or apron

ART PRINCIPLES

- Value (pages 30–31)
- Light Source (page 30)

PAINTING TECHNIQUES

- Underdrawing and Underpainting (page 63)

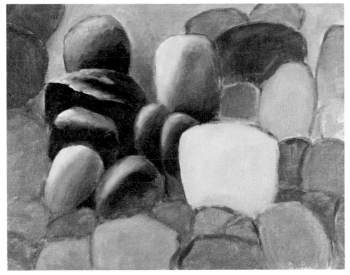

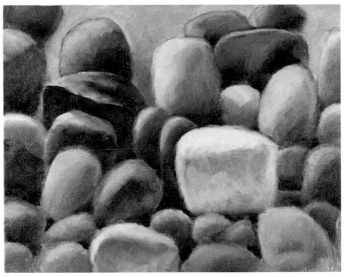

4 Start Adding Blended Values

Start adding and blending lights and darks, using both nos. 2 and 8 filberts. Work rock by rock and start filling the background with values.

5 Blend the Rocks and Add Darks Between

Finish blending the values of the rocks with nos. 2 and 8 filberts.

With a no. 2 filbert, make adjustments and add more darks between the rocks to give them better definition.

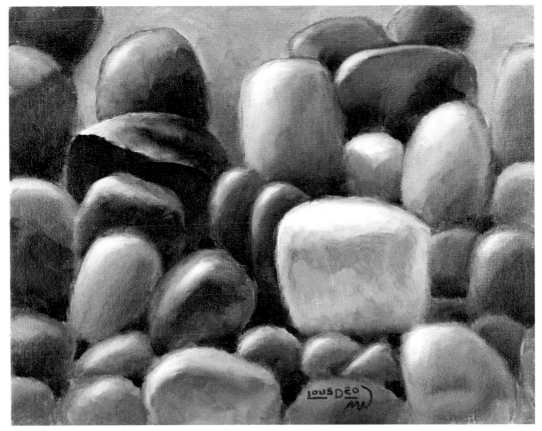

Rocks Along the Shore
oil on canvas mounted on board
8" × 10" (20cm × 25cm)

6 Add Highlights

To finish, add Titanium White for highlights with a no. 2 filbert. Sign and date your painting.

Sunset Beach

There is nothing quite like being on a tropical beach as the sun is setting. Use analogous colors (colors that lie next to each other on the color wheel) in this demonstration. You'll need to blend the sky and water while the paint is still wet, so be prepared to complete Steps 1–9 in one painting session.

Materials

Surface
12" × 9" (30cm × 23cm) canvas on board

Paints
Cadmium Orange Hue, Cadmium Red Hue, Cadmium Yellow Light, Cadmium Yellow Medium, Magenta, Titanium White

Brushes
no. 2 or ¼-inch (6mm) flat
no. 8 or ½-inch (12mm) filbert
no. 4 rigger

Other Supplies
palette, brush wash with water, palette knife, rag or paper towels, easel

Optional Supplies
thinner, medium, palette cups, mahlstick, smock or apron

1 **Place the Sun and Add Light Yellow Around the Sun and Water**
Use a no. 8 filbert to paint a Titanium White circle for the sun. Continue using the no. 8 filbert in Steps 2–7.

Paint a light yellow mix of Titanium White and Cadmium Yellow Light around the sun and the water under the sun. Add water or thinner to allow the paint to flow better when painting.

2 **Add Yellow and Yellow-Orange**
Paint Cadmium Yellow Light around the sun and in the water. At this stage, place the paints, but don't blend them on the painting surface.

Paint Cadmium Yellow Medium around the glowing sun and water.

ART PRINCIPLES
• Analogous Colors (page 33)

PAINTING TECHNIQUES
• Wet-Into-Wet (page 52)
• Wet-Into-Dry (page 53)

What a Bright Idea!

To paint this tropical sunset with bright, brilliant colors, use the paint colors recommended for this demonstration. If you use different colors or student grade paints, you may not achieve the same results.

Add Orange-Yellow
Paint a mixture of Cadmium Yellow Medium and Cadmium Orange Hue around the sun and water.

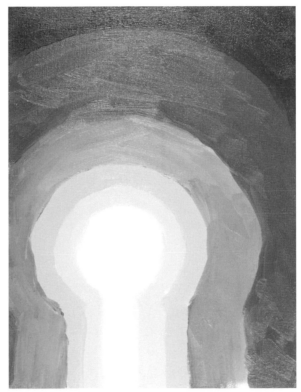

Add Orange, Then Red
Paint Cadmium Orange Hue around the sun and water. Add Cadmium Red Hue to the sky.

Blend the Sky
Clean the brush thoroughly, then blend the sky colors, starting at the white center and working out.

Blend the Water
Clean the brush thoroughly. Using up-and-down strokes to blend the paint, work right to left starting at the lightest part under the sun. Clean the brush and repeat, working left to right from the lightest part under the sun.

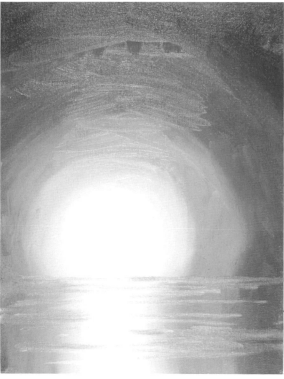

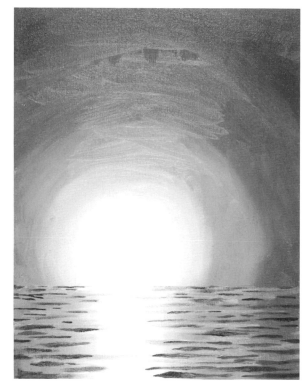

7 Create Wave Lines

With narrow, horizontal brushstrokes, create wave lines using only the paint that is on the painting surface; brush through the paint previously laid down with thin, horizontal brushstrokes.

8 Add Lights and Darks to the Waves

With a no. 2 flat, dab or streak Titanium White in the water under the sun. Next add Magenta streaks to the waves, making them larger the closer they get to the bottom.

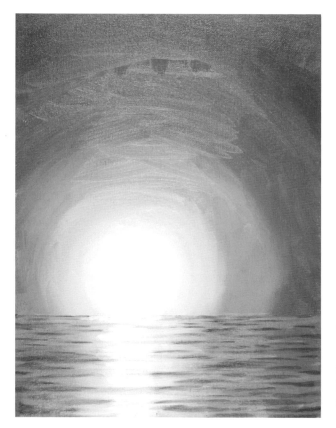

9 Soften the Dark Waves

Using a no. 8 filbert, gently brush over the dark waves with horizontal strokes to soften their appearance. Let the paint dry before proceeding to the next step.

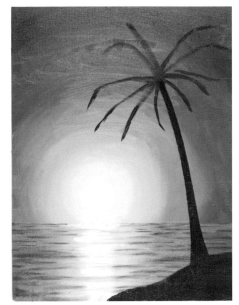

10 **Paint the Basic Structure of the Tree**
Painting wet-into-dry and starting with the trunk, use a no. 2 flat and Magenta to create the basic structure of the tree and ground.

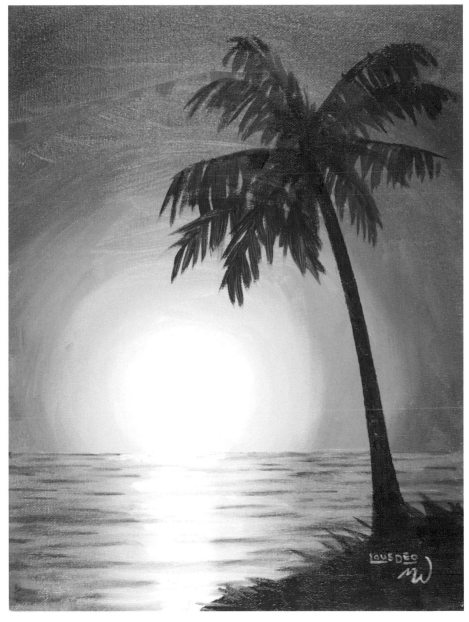

11 **Add Leaves and Grass**
Paint tree leaves and grass with Magenta using a no. 2 flat. Let the painting dry, then sign and date it with a no. 4 rigger.

Tropical Sunset
oil on canvas on board
12" × 9" (30cm × 23cm)

Mountains With Primary Colors

This demonstration will show just how much you can do with a limited palette. You'll use only the three primary colors plus white to mix all of the colors represented in this beautiful mountain scene. You'll learn how to use warm colors to suggest sunlit areas and cool colors for the shadowed regions.

You can build your scene in a horizontal or vertical format, depending on the feeling you want to achieve. The horizontal format will give the scene a calm, peaceful feeling, emphasizing the sturdiness and stability of the mountains. The vertical format emphasizes the height and power of the mountains and creates a feeling of awe.

Materials

Surface
9" × 12" (23cm × 30cm) primed canvas

Paints
Lemon Yellow, Permanent Rose, Phthalo Blue (Red Shade), Titanium White

Brushes
no. 10 or ¾-inch (19mm) flat
no. 2 or ¼-inch (6mm) filbert
no. 8 or ½-inch (12mm) filbert
no. 4 rigger

Other Supplies
palette, brush wash with water, palette knife, rag or paper towels, easel

Optional Supplies
thinner, medium, palette cups, mahlstick, smock or apron

ART PRINCIPLES

- Primary Colors (page 32)
- Color Temperature (page 34)

PAINTING TECHNIQUES

- Creating Brushstrokes (page 49)

1 Paint the Sky
Prime the canvas surface with gesso, but leave it white, without a ground. Mix Phthalo Blue (Red Shade) and Titanium White, then thin the mixture with thinner or water. Apply this to the top part of the canvas with a no. 10 flat using vertical strokes. For this stage, the paint consistency should be thin enough that you can see the canvas underneath.

Let It Dry!
When adding bright whites to a painting, let previous paint applications dry, or the white might mix with the undercolor.

2 Paint the Mountains

Mix Titanium White and Permanent Rose with a little Phthalo Blue (Red Shade). Paint in the shape of the mountains with a no. 8 filbert. Use a somewhat thicker paint consistency than in the previous step.

3 Paint the Foreground and Mountains

Mix Titanium White and Lemon Yellow with Permanent Rose to make a yellow-orange. Add this mixture to the foreground with a no. 8 filbert. The light source is coming from the upper left, so add some of this warm color to the sunlit side of the mountains.

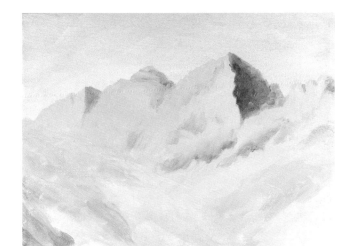

4 Add Green to the Hills

Mix Titanium White, Lemon Yellow and Phthalo Blue (Red Shade) to make green. With a no. 8 filbert, add this green to the foreground, following the contour of the hills.

5 Add Cool Colors to the Mountains

Add shadows to the right sides of the mountains with a mixture of Phthalo Blue (Red Shade), Permanent Rose and Titanium White applied with a no. 2 filbert.

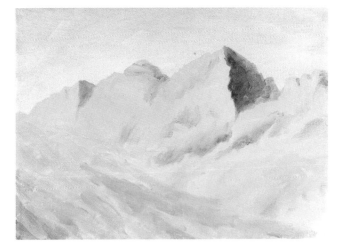

6 Add Bright Foreground Colors

With a no. 2 filbert, add a yellow-orange mixture of Lemon Yellow and Permanent Rose to the foreground. The bright, vibrant colors will enhance the depth of your painting.

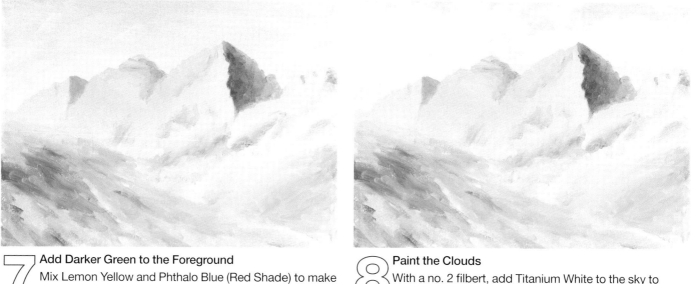

7 Add Darker Green to the Foreground

Mix Lemon Yellow and Phthalo Blue (Red Shade) to make a dark green. Add this green to the foreground areas with a no. 2 filbert.

8 Paint the Clouds

With a no. 2 filbert, add Titanium White to the sky to suggest clouds. Use soft, white shapes for the clouds. Sharply defined edges would change the composition of the painting, drawing unnecessary attention to the sky.

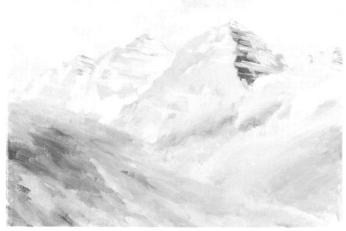

9 Add Snow to the Mountains

Add white to the mountains, using the edge of a no. 2 filbert to apply the paint.

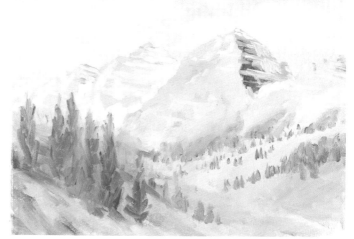

10 Paint the Trees

Use a mixture of Phthalo Blue (Red Shade), Lemon Yellow and Permanent Rose for the green of the trees. To paint the small trees, hold the no. 2 filbert so that the narrow surface of the bristles is vertical. Start at the base and pull the brush upward, tapering from thick to thin.

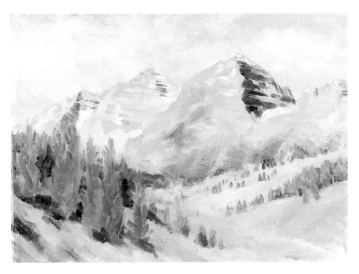

11 Add the Accents

With a no. 2 filbert, add a yellow-orange mixture of Lemon Yellow, Permanent Rose and Phthalo Blue (Red Shade) as accents to the distant hills. Add pink to the mountains with a mixture of Permanent Rose and Titanium White. Add shadows to the foreground and background trees with purple mixtures of Permanent Rose, Phthalo Blue (Red Shade) and Titanium White.

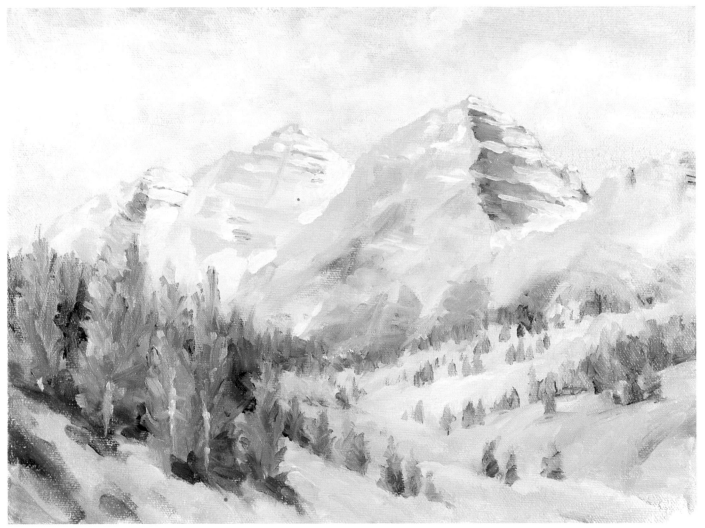

12 Add the Finishing Touches

Take a step back to observe your painting, then add finishing touches and adjustments. At this point, I lightened the dark of the mountains but kept the snow and also added more trees. The painting should feel complete with a depth expressed through contrasts and colors. Let the painting dry, then sign it with a no. 4 rigger.

Majestic
oil on stretched canvas
9" × 12" (23cm × 30cm)

Pear Still Life

Painting a simple still-life arrangement is a good way to examine the effects of light and shadows. A cardboard box or wood panels can be used to form the walls for your still life. An adjustable desk lamp is useful for creating a clear light source. In this demonstration, the light source is from the extreme left, casting long shadows to the right.

Once you have painted pears, consider setting up other still-life studies. Here are some ideas to try: floral arrangements, an assortment of antiques, candles, glass vases or other knick-knacks. The ideas are endless. Each new arrangement offers a play of light and shadows with textures.

1 **Apply a Ground**
Use a rag to apply diluted Burnt Sienna over the painting surface to create a light, transparent ground.

Watch the DVD

Watch the accompanying DVD to see how I set up and paint a similar still-life painting.

Materials

Surface
9" × 12" (23cm × 30cm) canvas on board

Paints
Burnt Sienna, Cadmium Yellow Light, Cerulean Blue, Magenta, Sap Green, Titanium White, Yellow Ochre

Brushes
no. 8 or ½-inch (12mm) flat
no. 2 or ¼-inch (6mm) filbert
no. 4 or 5/16-inch (8mm) filbert
no. 4 rigger

Other Supplies
palette, brush wash with water, palette knife, rag, easel, 3 pears, 3 wood panels or a cardboard box, adjustable desk lamp

Optional Supplies
thinner, medium, palette cups, mahlstick, smock or apron

ART PRINCIPLES

- Values (pages 30–31)
- Light Source (page 30)
- Composition (pages 38–41)

PAINTING TECHNIQUES

- Alla Prima (page 51)

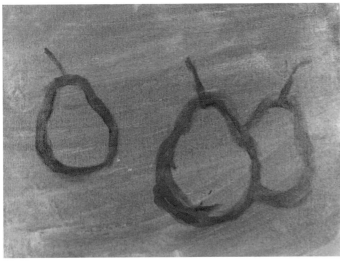

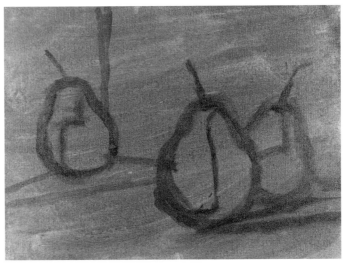

Sketch the Pears
Use a no. 4 filbert and Burnt Sienna to sketch the shape of the pears including the stems.

Add Structure and Shadow Lines
Add lines indicating the box structure and lines for the shadows including those on the pears.

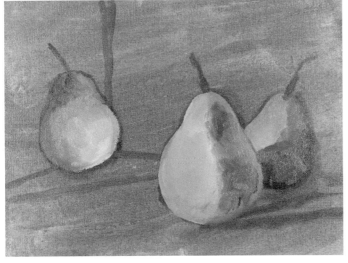

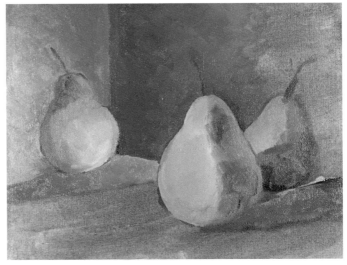

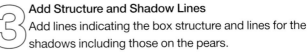

Paint the Pears
Mix Cadmium Yellow Light, Sap Green, Cerulean Blue, Titanium White, Magenta and Burnt Sienna to create a range of warm green colors. Use a no. 4 filbert to paint the pears.

Paint the Shadow Areas of the Sides and Bottom
Mix Yellow Ochre, Burnt Sienna, Titanium White, Cerulean Blue and Magenta to create a range of warm brown colors. Use a no. 8 flat to paint this color in the individual regions of the shadows.

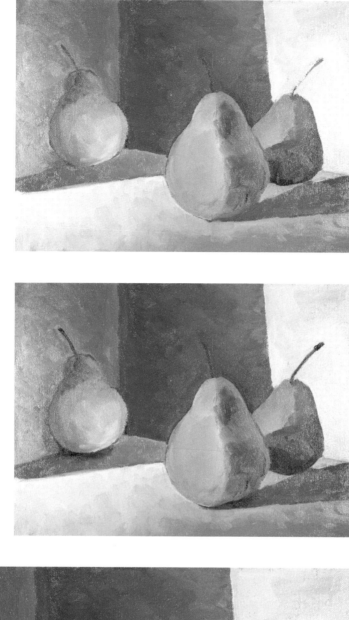

6 Add the Lighter Areas of the Sides and Bottom

Mix a range of tan colors with Titanium White, Yellow Ochre, Magenta and Burnt Sienna, then paint the bottom and sides with a no. 8 flat and no. 4 filbert.

7 Add Subtle Darks

With a no. 4 filbert, add Burnt Sienna in the shadows. Use a no. 2 filbert for the pear stems.

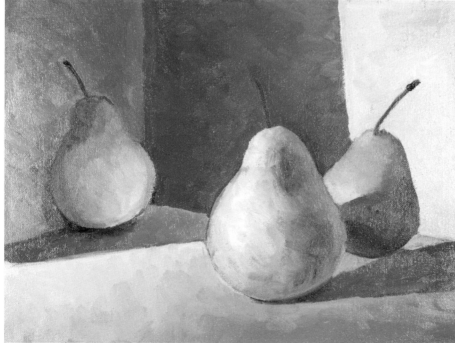

8 Add Lighter Areas to the Pears

Add warm greens to the pears with mixtures of Titanium White, Cadmium Yellow Light and Sap Green and a no. 4 filbert. Smooth the form of the pears during the process.

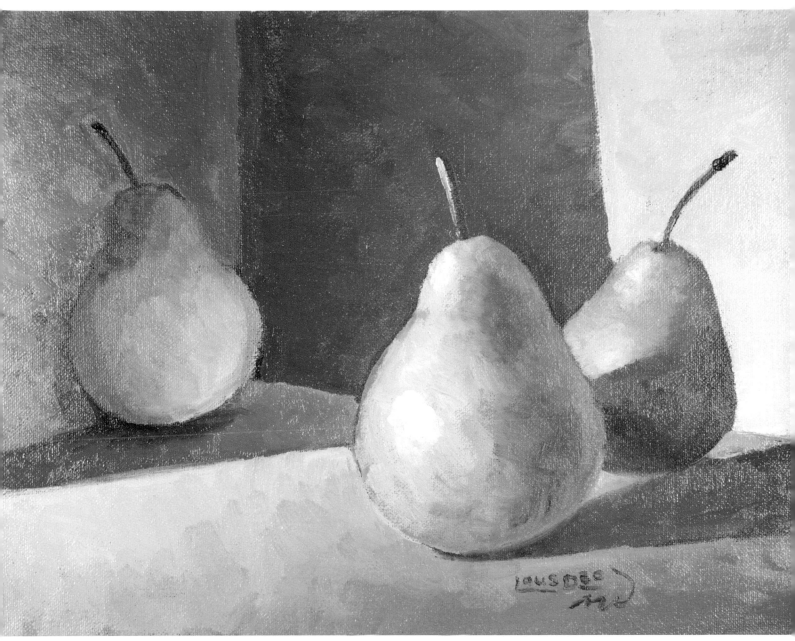

9 Add Highlights and Adjustments

Add highlights to the pears with Titanium White and make minor adjustments such as adding highlights and lights to the nearest stem. Let the paint dry, then add your signature with a no. 4 rigger.

Still Life With Pears
oil on canvas mounted on board
9" × 12" (23cm × 30cm)

Sunflowers

You can approach this demonstration in one of several ways: paint the flowers over the background (positive painting); or try painting the surface yellow, then fill in the rest of the background around the flowers (negative painting); or try a combination of the two techniques.

For this composition, the stalks and leaves are more implied and less detailed than the flowers. Keep in mind while you are painting that the light source is coming from the upper left.

1 **Sketch the Basic Flower Shapes**
Using a 2B or charcoal pencil, sketch the placement of the flower shapes with circles.

2 **Add Details to the Sketch**
Sketch the center portion and petals of the flowers.

Materials

Surface
20" × 16" (51cm × 41cm) stretched canvas

Paints
Burnt Sienna, Cadmium Orange Hue, Cadmium Yellow Hue, Cadmium Yellow Light, Cerulean Blue, Sap Green, Titanium White

Brushes
no. 4 or ⁵/₁₆-inch (8mm) flat
no. 8 or ½-inch (12mm) filbert
no. 4 rigger

Other Supplies
palette, brush wash with water, palette knife, rag or paper towels, easel, kneaded eraser, 2B pencil or charcoal pencil, spray fixative

Optional Supplies
thinner, medium, palette cups, mahlstick, smock or apron

ART PRINCIPLES

• Color Temperature (page 34)

PAINTING TECHNIQUES

• Mixing Paint (page 45)
• Positive and Negative Painting (page 56)

Let Your Creativity Out

After you've completed this demonstration, try another painting using your own silk or live sunflowers as visual reference. You will notice subtle differences that are not as easily seen when looking at a photo. Try setting up other floral arrangements if you like painting flowers.

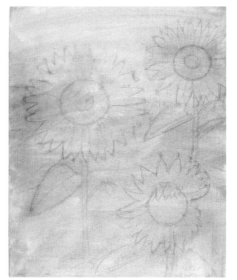

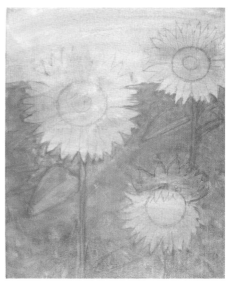

3 Finish the Underdrawing
Add more details to the scene and erase unwanted lines with a kneaded eraser. When finished, spray with fixative to prevent the paint from smearing the graphite.

4 Add the Ground Color
With a rag, smear Burnt Sienna diluted with water to create a ground. To keep the pencil lines visible, the paint needs to be transparent.

5 Paint the Green Areas
With a no. 8 filbert paint the green areas with a mix of Sap Green, Cadmium Yellow Hue, Titanium White and Cerulean Blue. Thin the paint with water or thinner so the pencil lines remain visible.

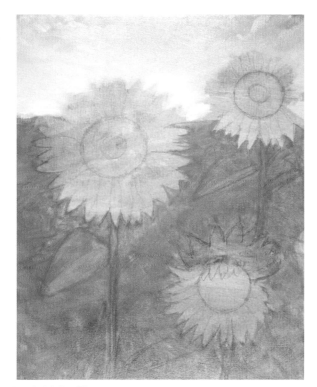

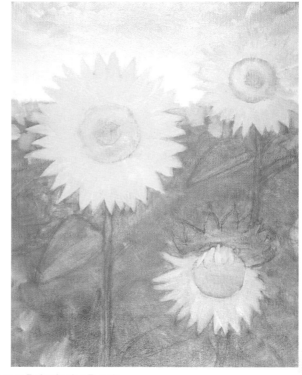

6 Add the Sky
Using a no. 8 filbert, paint the sky with Cerulean Blue and Titanium White. The lower portion of the sky is mostly white, the top mostly blue.

7 Paint in the Petals
With a mixture of Cadmium Yellow Hue and Titanium White, paint in the petals using a no. 8 filbert. Roughly paint the distant sunflowers using the same colors.

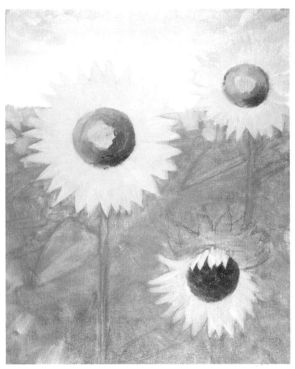

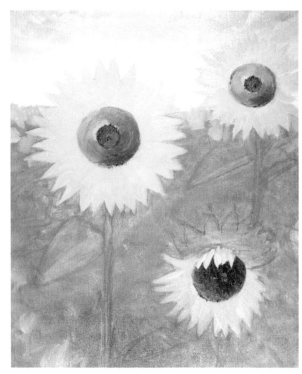

Start Painting the Flower Centers
With mixtures of Cadmium Orange Hue, Burnt Sienna, Titanium White and Sap Green, begin painting the flower centers. The light source for this subject is coming from the upper left. This will noticeably affect the shading of the convex centers of the top two flowers.

Add Darks to the Centers
Using the no. 4 flat, apply a mix of Burnt Sienna and Sap Green.

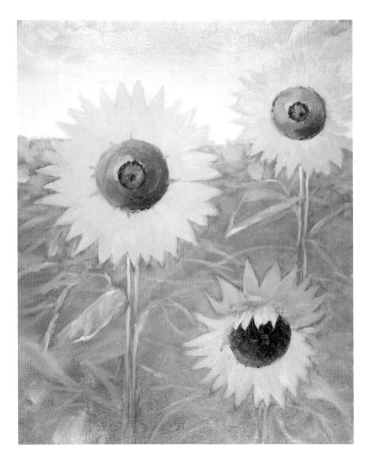

Add Light Green
Using both a no. 8 filbert and a no. 4 flat, apply mixtures of Sap Green, Cadmium Yellow Light and Titanium White to the leaves and stalks. Also add these light green colors to the flower centers and between the petals.

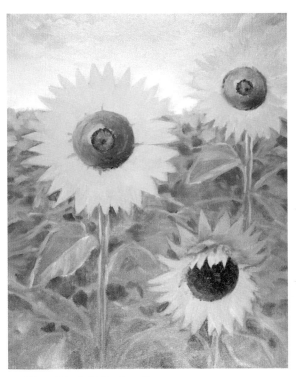

11 **Add Darker Greens**
Using a no. 8 filbert, apply a mix of Sap Green, Cerulean Blue and Burnt Sienna to the leaves and stalks.

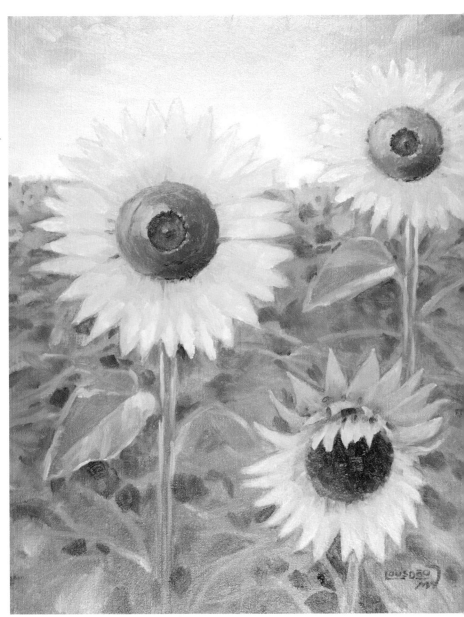

12 **Add Finishing Lights and Darks**
Using a no. 4 flat, make finishing adjustments of lights and darks. Add Cadmium Yellow Light to the outer parts of the petals, and Cadmium Yellow Hue to the inner petals. Let the painting dry, then sign and date it with a no. 4 rigger.

Field of Sunflowers
oil on stretched canvas
20" × 16" (51cm × 41cm)

Cloud Study

It's fun to try to capture clouds' ever-changing character. Keeping in mind the placement of the light source in the top right will help you create clouds with a three-dimensional quality. A photographed sky may look like a single flat color, but a painting expresses a sky best as an expanse of space that changes in both value and color. In this demonstration the sky is a midvalue French Ultramarine at the top graduating to light Cerulean Blue and Sap Green at the bottom.

Materials

Surface
8" × 10" (20cm × 25cm) canvas on board

Paints
Cerulean Blue, French Ultramarine, Permanent Rose, Sap Green, Titanium White

Brushes
no. 12 or 1-inch (25mm) flat

no. 4 or 5/16-inch (8mm) filbert

Other Supplies
palette, brush wash with water, palette knife, rag or paper towel, easel

Optional Supplies
thinner, medium, palette cups, mahlstick, smock or apron

ART PRINCIPLES

- Light Source (page 30)

PAINTING TECHNIQUES

- Mixing Paint (page 45)

1 Start Painting the Sky
With a mixture of Titanium White, Cerulean Blue and Sap Green, paint the sky using a no. 12 flat. Start at the bottom of the canvas and paint just past the middle. To mix the colors, start with Titanium White because the dominant blue and green will want to take over, making the sky color hard to tame. Add a drop or two of water or thinner to the paint to improve the flow. Create a thin application, but not as thin as a wash.

2 Add the Top of the Sky
With a mix of Titanium White and French Ultramarine, start painting from the top down, gradually adding Cerulean Blue as you work down to meet up with the bottom half of the sky. With a clean brush, work over the entire sky, top to bottom, to blend it more evenly.

Paint the Cloud Shapes

Using a no. 4 filbert, add the cloud shapes with a mixture of Titanium White, Cerulean Blue, French Ultramarine, Sap Green and a hint of Permanent Rose. As you apply the paint, it's OK if this mixes with the paint previously laid down for the sky.

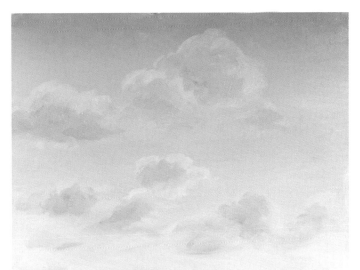

Add Darker Values to the Clouds

Mix the Step 3 colors using less white to create a darker bluish gray, then paint the shadowed areas of the clouds. The light source is coming from the upper right, so the clouds will be mostly dark in the lower left areas.

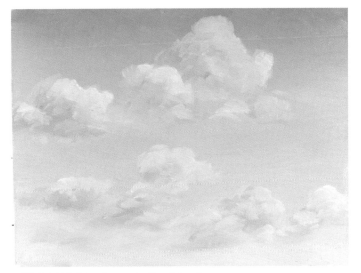

Add Lighter Areas to the Clouds

With Titanium White, mix in the lighter areas of the clouds. The brightest areas will be in the upper right of individual clouds. Clean your brush and replace the brush wash water for the best results.

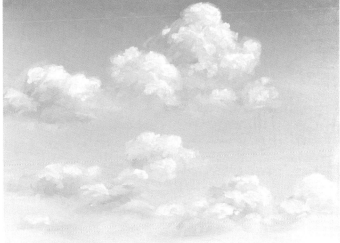

Finish With Highlights

Apply thick Titanium White for highlights in the top right of the individual clouds. Do not mix the white highlight with the previously laid colors. The Titanium White should remain pure.

Same Colors, Different Mix

Turn to page 7 to see this painting completed with a foreground. Mark mixed the same colors in different proportions to create the foreground.

Landscape With Cottage

This landscape scene is from a photo I took of farmland not far from where we live. I added the cottage for interest and drew upon my experience painting plein air landscapes to create a sense of believ-ability even though the scene was painted indoors.

Materials

Surface
9" × 12" (23cm × 30cm) canvas on board

Paints
Burnt Sienna, Cadmium Orange Hue, Cadmium Red Hue, Cadmium Yellow Hue, Cerulean Blue, Dioxazine Purple, French Ultramarine, Per-manent Rose, Sap Green, Titanium White, Yellow Ochre

Brushes
no. 2 or ¼-inch (6mm) filbert
no. 8 or ½-inch (12mm) filbert
no. 2 round
no. 4 rigger

Other Supplies
palette, brush wash with water, pal-ette knife, rag or paper towels, easel, 2B pencil or charcoal pencil, kneaded eraser, spray fixative

Optional Supplies
thinner, medium, palette cups, mahl-stick, smock or apron

1 Start Drawing the Scene
Begin with a 2B pencil by drawing the horizon and the water's edge as the basis for the scene.

2 Draw the Trees and Path
Draw the trees and their reflections in the water. Add the path reced-ing into the distance.

3 Add the Cottage
Draw the cottage along with the reflection in the water. Spray with fixative.

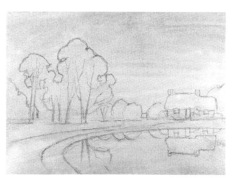

4 Apply Ground Color
Using a rag, smear Burnt Sienna thinned with water over the entire surface as the ground.

The demonstration continues on page 86.

ART PRINCIPLES

- Linear Perspective (pages 28–29)
- Atmospheric Perspective (page 31)
- Color Temperature (page 34)

PAINTING TECHNIQUES

- Scumbling (page 51)

Painting Trees

MINI DEMONSTRATION

While you can just paint trees directly onto the painting surface without an underdrawing or underpainting, creating a detailed drawing first will help guide you as you paint.

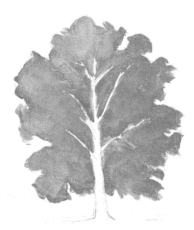

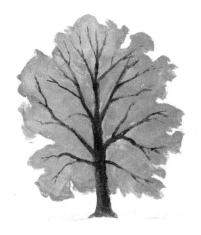

1 Paint the Leaves
After drawing the tree and branches and spraying the surface with fixative, paint the regions of the leaves with a mix of Cadmium Yellow Light and Sap Green, using a no. 4 filbert. Avoid painting over the trunk and branches.

2 Paint the Trunk and Branches
Paint over the trunk and branches with a mix of Burnt Sienna and Cadmium Orange Hue and a no. 2 filbert and a no. 2 round, improving and adding some branches as needed. Tree trunks and branches taper or become thinner as they grow outward.

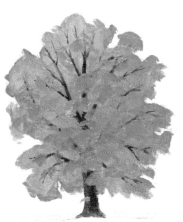

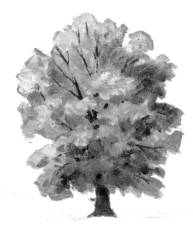

3 Add More Leaves
Add leaves over the previous leaves and branches with the green mix of Cadmium Yellow Light and Sap Green, using a no. 2 filbert. If there are parts of the branches you don't like, try painting over them with leaves.

4 Paint Lights, Darks
Add more Cadmium Yellow Light to the green mix to create warm light areas and add Phthalo Blue (Red Shade) to the green and brown mixes to create cool dark areas, including leaves, trunk and branches with a no. 2 filbert.

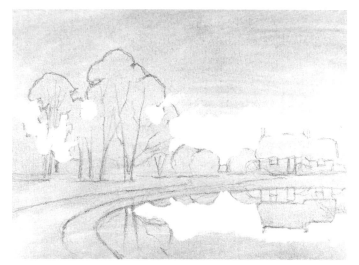

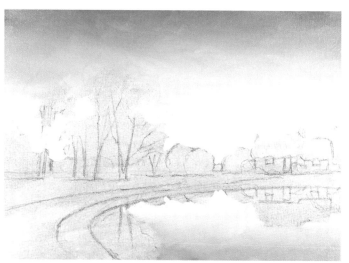

Start Painting the Sky and Water

Starting near the horizon, paint the sky using a no. 8 filbert with Titanium White and a touch of Permanent Rose. Start painting the water with the same paint mixture but with the addition of Cerulean Blue. The water is a little darker and bluer than the sky that it reflects.

Fill in the Sky and Water

Fill in the rest of the sky with a no. 8 filbert, adding more Cerulean Blue to the paint mixture as you paint upward. Add French Ultramarine at the top. Continuing with the no. 8 filbert, paint the water. Reflecting the sky, the water is lighter at the top and darker at the bottom.

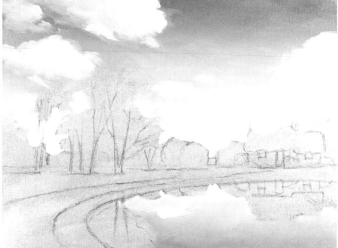

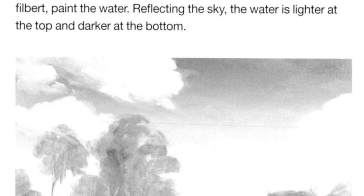

Add the Clouds

Paint the clouds using a no. 8 filbert loaded with Titanium White. The light source is coming from the upper right, so the clouds are whitest in their top right areas.

Paint the Middle Value Colors

With a no. 8 filbert, paint different regions of the scene with a mixture of Yellow Ochre, Cadmium Yellow Hue, Cadmium Orange Hue, Cadmium Red Hue, Sap Green, Burnt Sienna and Titanium White.

Reflections

Though images and their reflections share similar values and colors, reflections don't need as much detail and precision as the images they reflect.

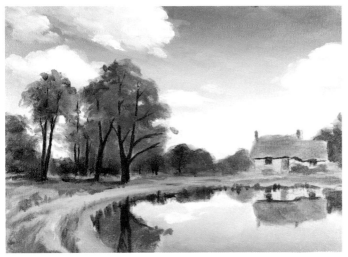

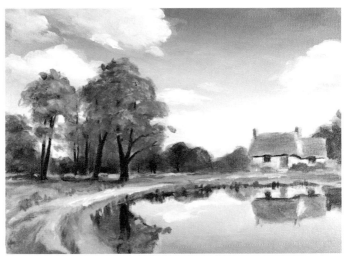

9 Paint More Middle Values and Some of the Darker Values
Using a no. 2 filbert, apply different combinations of the colors in the previous step plus Dioxazine Purple. For tree trunks and branches, mix Dioxazine Purple with Burnt Sienna and apply the mix with a no. 2 filbert and a no. 2 round. Scumble in places by lightly dragging the no. 2 filbert with undiluted paint.

10 Add the Lighter Details
Using a no. 2 filbert, paint lighter details such as parts of the cottage, some of the path and some of the leaves using various combinations of colors already used lightened with Titanium White. Apply a mixture of Titanium White and Permanent Rose around the cottage along the water's edge.

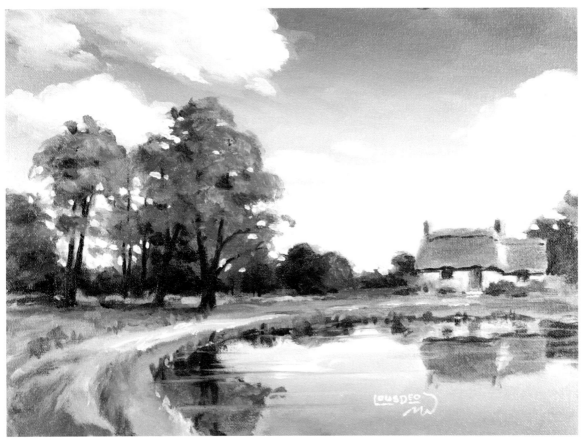

11 Finish Adding the Details
Darken and lighten areas around the trees and cottage, and make thin horizontal streaks on the water by dragging the no. 2 filbert through the wet paint. Let the painting dry, then sign and date it with a no. 4 rigger.

Patton's Puddle
oil on canvas on board
9" × 12" (23cm × 30cm)

Seascape With Boats

This is a simple composition, but it will make an impressive piece of artwork when you are finished. Notice the subtle transitions of colors and values from left to right in the sky, trees and water. Without these transitions, the painting might turn out flat, but, with them, you will create a beautiful, soothing water scene.

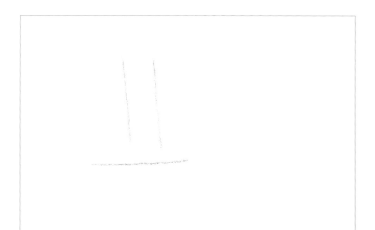

1 Start Drawing the Boat
With a 2B pencil, start drawing the boat with a horizontal line, going slightly up on the right for the hull. Two vertical lines, leaning at the top and slightly to the left will form the masts.

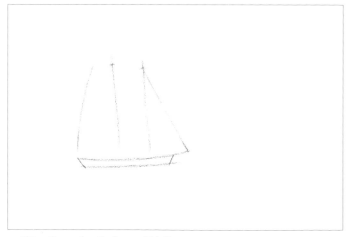

2 Form the Sails and Hull
Add lines to start forming the sails and hull. Measure the length of the hull and mark the height of the masts to approximately the same length.

Materials

Surface
9" × 12" (23cm × 30cm) canvas on board

Paints
Cadmium Yellow Medium, Cerulean Blue, Dioxazine Purple, Magenta, Phthalo Green (Blue Shade), Prussian Blue, Titanium White, Yellow Ochre

Brushes
no. 2 or ¼-inch (6mm) filbert
no. 4 or ⁵/₁₆-inch (8mm) filbert
no. 4 rigger

Other Supplies
palette, brush wash with water, palette knife, rag or paper towels, easel, 2B or charcoal pencil, kneaded eraser, spray fixative

Optional Supplies
thinner, medium, palette cups, mahl-stick, smock or apron

ART PRINCIPLES
- Value (pages 30–31)
- Color Temperature (page 34)
- Composition (pages 38–41)

PAINTING TECHNIQUES
- Wet-Into-Wet (page 52)
- Wet-Into-Dry (page 53)

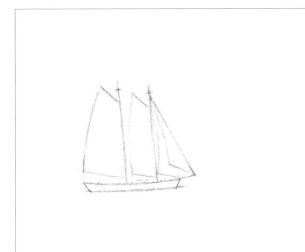

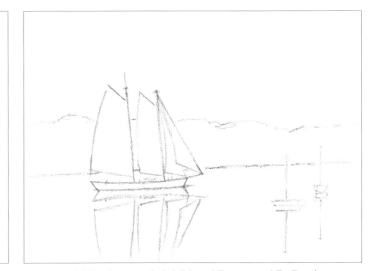

3 Add Features to the Boat
Start adding features to the boat, including the sails and the deck.

4 Add Background, Additional Boats and Reflections
Add the background trees and shoreline. Sketch in the smaller boats and add reflections to the boats. Erase any unwanted lines with the kneaded eraser and spray with fixative.

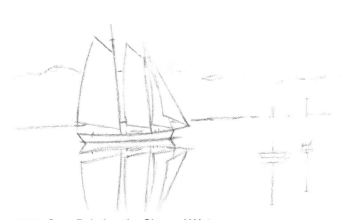

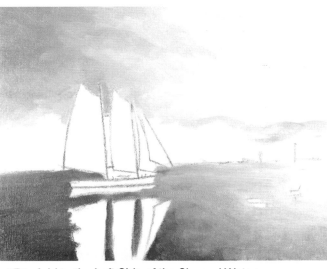

5 Start Painting the Sky and Water
With a mixture of Titanium White and Cerulean Blue, start painting the sky and water with a no. 4 filbert. The sky and water should be noticeably lighter on the right side.

6 Add to the Left Side of the Sky and Water
Develop the left side of the sky with a no. 4 filbert and a mix of Titanium White, Dioxazine Purple and Prussian Blue. Add to the left portion of the water with a mix of Titanium White, Dioxazine Purple, Prussian Blue and Phthalo Green (Blue Shade) and a trace of Cadmium Yellow Medium. The water should be darker than the sky above it.

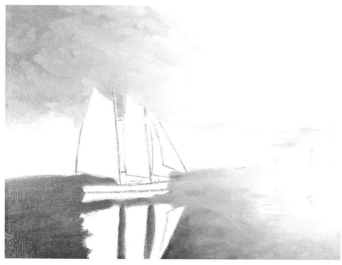

7 Add White to the Right Side of the Sky and Water

With a clean brush and water, add Titanium White to the right portion of the sky and water.

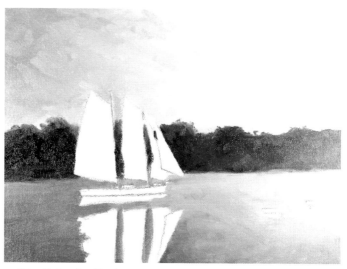

8 Paint the Background Trees

Starting on the left, paint in the background trees with a mix of Phthalo Green (Blue Shade), Cerulean Blue and Dioxazine Purple using a no. 4 filbert. Work to the right, gradually adding Magenta and Titanium White to the mix so that the extreme right looks purple-gray.

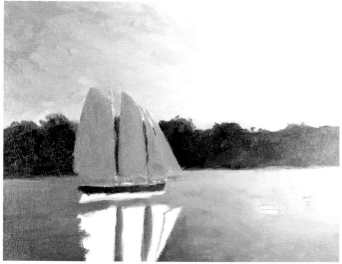

9 Paint the Sails and Hull

With a mix of Yellow Ochre, Magenta, Cerulean Blue, Dioxazine Purple and Titanium White, paint the sails using a no. 2 filbert. Paint the hull with a mix of Dioxazine Purple, Phthalo Green (Blue Shade), Cerulean Blue, Magenta and Titanium White. The hull is darker and cooler on the left.

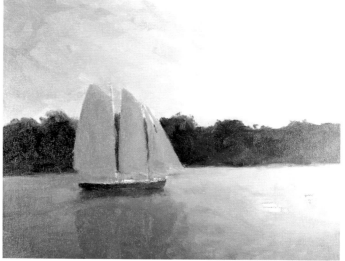

10 Add the Sails' and Hull's Reflections

With nos. 2 and 4 filberts, add the reflections of the sails and hull with the colors used for the sails and hull in Step 9 along with the water colors. The reflections are similar to the color and value of the water, the difference between the two becoming almost indistinguishable toward the bottom.

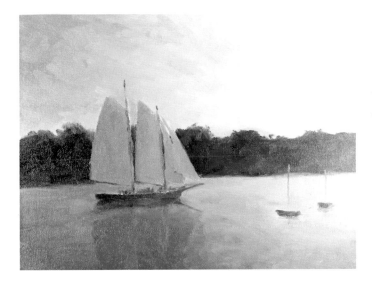

11 Paint the Smaller Boats and Masts

Paint the small boats, the masts of the large boat and some details with a mixture of Titanium White, Dioxazine Purple, Cerulean Blue and Prussian Blue. Use a no. 2 filbert and no. 4 rigger.

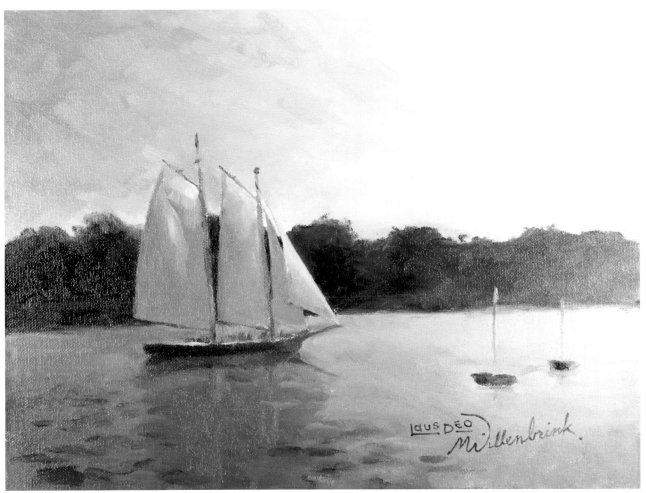

Morning Sail
oil on canvas on board
9" × 12" (23cm × 30cm)

12 Add Details and Elements

Add final details and elements including the boat trim and waves at the bottom with mixture of Dioxazine Purple, Cerulean Blue and Prussian Blue, using a no. 4 rigger for the thin lines and a no. 2 filbert for the wider strokes. Use a mixture of Titanium White with Cadmium Yellow Medium for the highlights of the sails. Let the paint dry, then sign and date the painting with a no. 4 rigger.

Springhouse in Summer

Working en plein air (see pages 58–59), whether for sketches or finished paintings, is a great way to observe a subject and become more aware of subtle color variations that may be lost in a photograph. Consider making it a goal to observe the different hues of green in nature as the sun moves across the sky and also as the seasons change.

Two-Point Perspective

Use two-point perspective to construct the buildings. The vantage point is such that the buildings are above the horizon, giving the impression of looking up at them. The left vanishing point is within the picture area, while the right vanishing point rests on the horizon beyond the border of the picture area. Try drawing this on the painting surface with charcoal or pencil, then spray with a fixative so the drawing doesn't smear.

Alternative Approach

If painting the buildings in two-point perspective requires more effort than you want to exert and you feel as though your brain may explode, try repositioning the buildings to a straight-on view.

Watch the DVD

Watch the accompanying DVD to see me create a similar landscape painting.

Materials

Surface
8" × 16" (20cm × 41cm) stretched canvas

Paints
Burnt Sienna, Cadmium Orange Hue, Dioxazine Purple, Lemon Yellow, Permanent Rose, Phthalo Blue (Red Shade), Phthalo Green (Blue Shade), Titanium White, Yellow Ochre

Brushes
no. 12 or 1-inch (25mm) flat
no. 4 or ⁵/₁₆-inch (8mm) filbert
no. 4 rigger

Other Supplies
palette, brush wash with water, palette knife, rag or paper towel, easel, 2B or charcoal pencil, kneaded eraser, spray fixative

Optional Supplies
thinner, medium, palette cups, mahl-stick, smock or apron

ART PRINCIPLES

- Linear Perspective (pages 28–29)
- Color Temperature (page 34)

PAINTING TECHNIQUES

- Positive and Negative Painting (page 56)

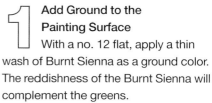

Add Ground to the Painting Surface
With a no. 12 flat, apply a thin wash of Burnt Sienna as a ground color. The reddishness of the Burnt Sienna will complement the greens.

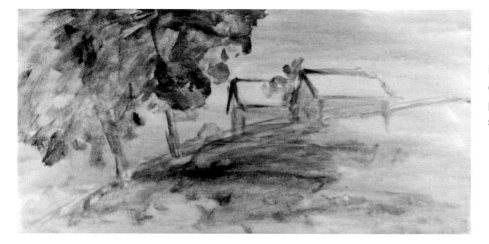

Sketch the Structures and Shadows
Using Phthalo Blue (Red Shade) and a no. 4 filbert, roughly sketch in the building shapes, trees and shadows. This will help you work out the placement of the elements if you haven't sketched them out ahead of time.

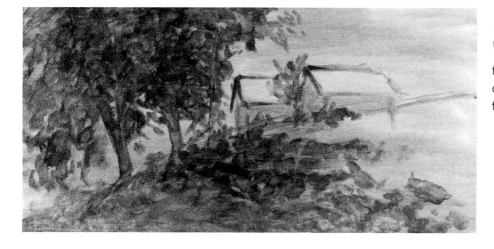

Add Darker Greens
Mix Phthalo Green (Blue Shade) and Yellow Ochre and use a no. 4 filbert to brush in the shadowed areas. You can add thinner to the paint to improve the flow. Gradually apply thicker paint.

Green Tips

To keep the greens looking fresh and pure, mix them with analogous colors (colors adjacent to green on the color wheel, blue and yellow in this case). To make green look natural and less garish, add a touch of its complement (red).

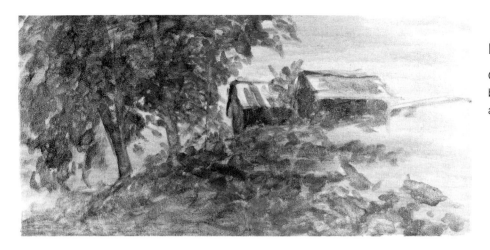

4 Add Browns

Mix Yellow Ochre with a little Permanent Rose and Phthalo Green (Blue Shade). Add paint to the building, trees and foreground grass with a no. 4 filbert.

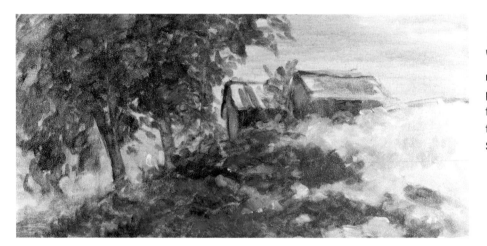

5 Add Lighter Greens

With a mix of Lemon Yellow, Phthalo Green (Blue Shade), Titanium White and Cadmium Orange Hue, paint in the bright green areas with a no. 4 filbert. Develop the shadowed areas further with a mixture of Phthalo Green (Blue Shade) and some of the other colors.

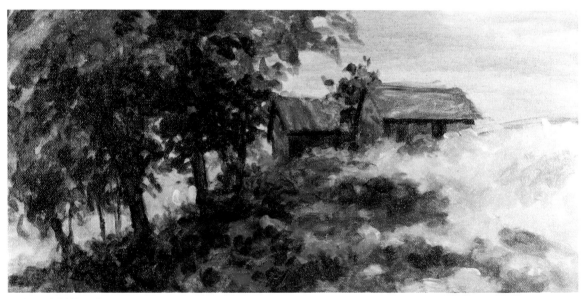

6 Add Purples

Add the dark purples with a mixture of Dioxazine Purple with a little Phthalo Blue (Red Shade) and Phthalo Green (Blue Shade) to the shadowed areas with a no. 4 filbert. Apply some purple mixtures to the buildings. Add some greens and Burnt Sienna to the trees and foreground.

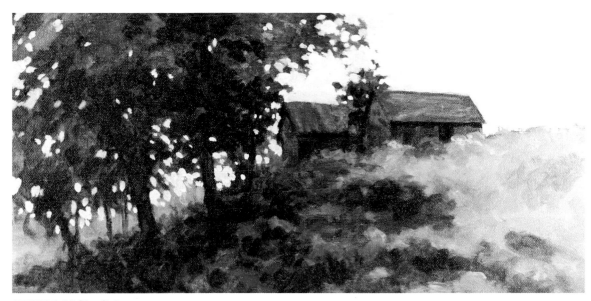

7 Add Sky Color

With a mix of Titanium White and a little Phthalo Blue (Red Shade), paint the sky using a no. 4 filbert. Create the small holes in the leaves of the trees by dabbing the paint onto the canvas with the edge of the brush.

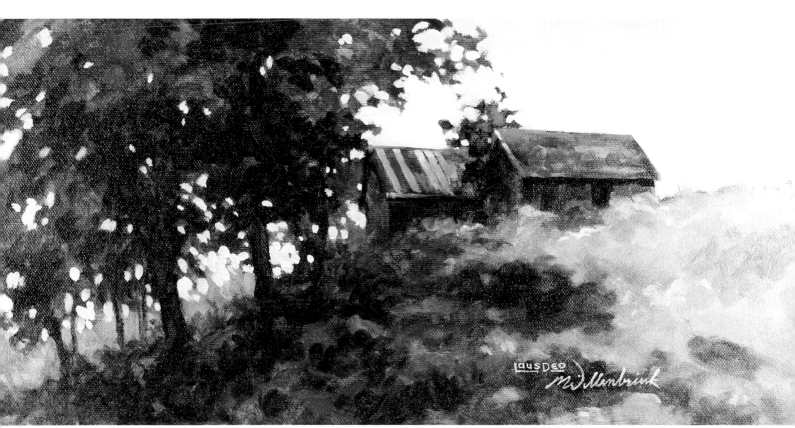

8 Add Final Details

Add final details and adjustments to the buildings and trees and add more blue in the upper sky. Write the date on the back of the painting. Let the paint dry, then sign the painting on the front with a no. 4 rigger.

Springhouse in Summer
oil on stretched canvas
8" × 16" (20cm × 41cm)

Twilight Gatehouse

You may recognize this subject from our previous book *Watercolor for the Absolute Beginner* or my video workshop *Drawing for the Absolute Beginner*, either of which can be referred to for more detailed drawing instructions.

The use of warm and cool colors gives this snow scene a cozy feeling. You can almost imagine people inside the building, sipping hot chocolate in front of a fire.

Materials

Surface
9" × 12" (23cm × 30cm) canvas on board

Paints
Burnt Sienna, Cadmium Yellow Hue, French Ultramarine, Magenta, Titanium White

Brushes
no. 12 or 1-inch (25mm) flat

no. 2 or ¼-inch (6mm) filbert

no. 8 or ½-inch (12mm) filbert

no. 10 or ¾-inch (19mm) filbert

no. 2 round

no. 4 rigger

Other Supplies
palette, brush wash with water, palette knife, rag or paper towels, easel, 2B or charcoal pencil, kneaded eraser, spray fixative

Optional Supplies
thinner, medium, palette cups, mahlstick, smock or apron

ART PRINCIPLES

- Structural Drawing (page 25)
- Color Temperature (page 34)
- Glowing Results (page 35)

PAINTING TECHNIQUES

- Scumbling (page 51)
- Using a Ground (page 62)

1 Draw the Basic Rectangles
Use a 2B pencil to draw the basic rectangular shapes of the structure, making sure the proportions are correct and the lines are perpendicular to one another.

2 Add to the Rectangles
Build on the basic rectangles, adding the window, the sides to the door and a triangle for the turret roof.

 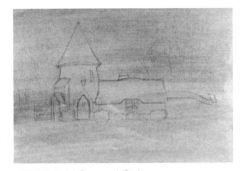

3 Refine Shapes and Add Architectural Elements
Refine the shapes. Add curves to the roof ledges and finish the door, window, gate and other elements.

4 Add Trees and Shrubs and Erase Unwanted Lines
Sketch in the trees and shrubs and erase unwanted lines with a kneaded eraser. Spray with a fixative to prevent graphite from smearing as you paint over the drawing.

5 Add Ground Color
Smear diluted Magenta with a rag to form a ground. Create a transparent layer so that the pencil drawing shows through. Let the paint dry (a thin layer shouldn't take long).

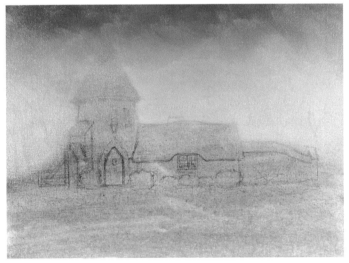 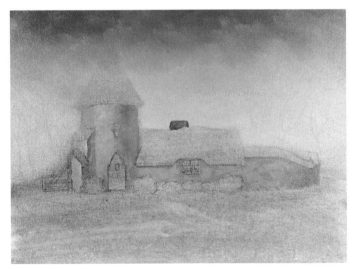

6 Paint the Sky
Paint the sky with a no. 12 flat and a mix of Titanium White and French Ultramarine. Work from top to bottom so that there is more French Ultramarine at the top. Wipe down the French Ultramarine layer with a rag, smoothing and removing some of the paint so that the Magenta shows through. Go back over the entire sky with a clean, dry brush to add brushstrokes.

7 Paint the Stonework
Paint a basecoat on the stonework and chimney with a mixture of Burnt Sienna, Cadmium Yellow Hue, Magenta, French Ultramarine and Titanium White. Mix in more Cadmium Yellow Hue, Magenta and Titanium White to paint the warmer light areas. Mix in more Burnt Sienna and French Ultramarine for the cooler dark areas. Don't paint the individual stones yet.

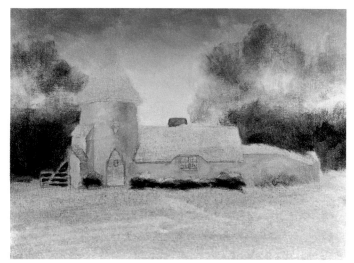

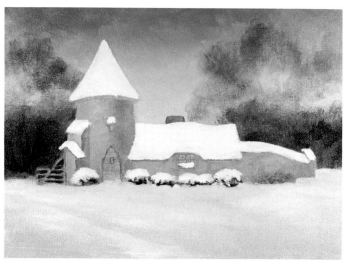

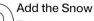

8 Paint the Background Darks and Shrubs
Using a no. 8 filbert, scumble in a mixture of Burnt Sienna and French Ultramarine to add background darks of the tree shapes and shrubs. In some places the scumbling can be gently smoothed.

9 Add the Snow
Paint the snow with a mixture of Titanium White, French Ultramarine and Magenta. Use nos. 2, 8 and 10 filberts, depending on how broad or detailed the application. Use larger brushes for larger areas. Use a rag to wipe down the paint in places such as the lower foreground to expose the Magenta ground.

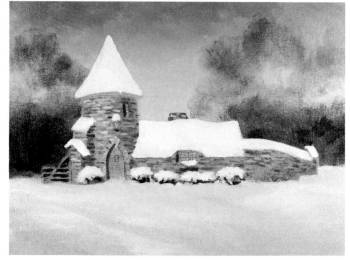

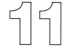

10 Paint the Stone Details
Paint the stone details with a no. 2 round and the stonework color from Step 7, making it darker in some places and lighter in others. The idea is to imply stones rather than paint every one.

11 Paint the Building Trim and Shadows
Using a no. 2 filbert and a no. 2 round, paint the gate, door and other trim work, including the shadows under the rooflines, with a mix of French Ultramarine and Burnt Sienna.

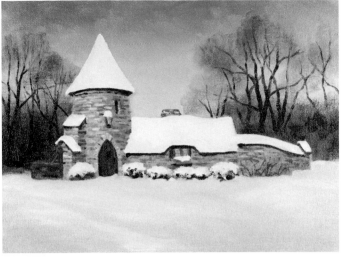

12 Add Tree Branches and Vines

Paint tree branches in the background and vines in the front of the building with French Ultramarine and a no. 2 round.

13 Add Snow Details

Using the snow color from Step 9, scumble smoke above the chimney and snow on the background bushes, building and vines using a no. 2 filbert. Use a no. 2 round for snow on the gate. Apply subtle highlights with pure Titanium White and a no. 2 filbert.

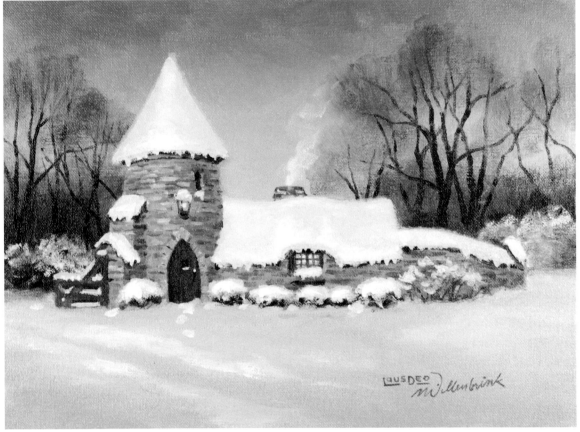

14 Finish With Snow Details and Lights for the Lantern and Window

Add snow details including icicles with Titanium White and French Ultramarine, using a no. 2 filbert and a no. 2 round. Using a no. 2 round, mix Cadmium Yellow Hue with Titanium White and paint in the lantern and window. Add some of the yellow around both the lantern and window for reflected light. Switch to Burnt Sienna to paint the mullion around the glass panes. Let the painting dry, then sign and date it with a no. 4 rigger.

Twilight Gatehouse
oil on canvas mounted on board
9" × 12" (23cm × 30cm)

Lion

When painting animals, it's fun to try to capture their attributes through their eyes or the tilt of the head or through the colors you chose to represent them. For this lion demonstration, I chose colors to show the authority and kingship that the lion symbolizes. Note that the light shining on the lion is coming from the upper right.

Materials

Surface
12" × 16" (30cm × 41cm) stretched canvas

Paints
Burnt Sienna, Cadmium Orange Hue, Cadmium Red Hue, Cadmium Yellow Hue, Magenta, Permanent Rose, Phthalo Blue (Red Shade), Titanium White, Yellow Ochre

Brushes
no. 2 or ¼-inch (6mm) filbert
no. 4 or ⁵⁄₁₆-inch (8mm) filbert
no. 8 or ½-inch (12mm) filbert
no. 4 rigger

Other Supplies
palette, brush wash with water, palette knife, rag or paper towels, easel, 2B or charcoal pencil, kneaded eraser, spray fixative

Optional Supplies
thinner, medium, palette cups, mahl-stick, smock or apron

ART PRINCIPLES
- Value (pages 30–31)
- Light Source (page 30)

PAINTING TECHNIQUES
- Scumbling (page 51)

1 Sketch the Basic Profile
Using a 2B or charcoal pencil, sketch the basic shape of the profile along with a line to define the placement of the eye.

2 Add More Elements
Add the shape of the mane and the ear to the profile.

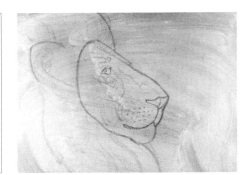

3 Start Adding Details
Add details such as the nose and refine the form, erasing some of the line work with a kneaded eraser.

4 Add More Details and Adjustments
Add lines to indicate the shadows and fur along with other details including facial contours. Spray with fixative to prevent the graphite from smearing as you paint over your drawing.

5 Add the Ground Color
Use a rag to smear Burnt Sienna diluted with water as a ground. The paint should be transparent so that the pencil drawing is visible through the paint.

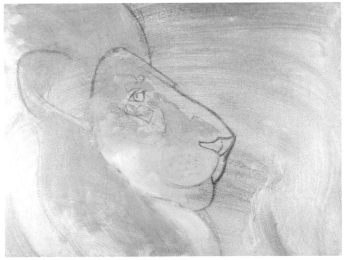

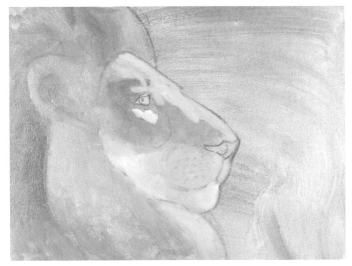

6 Start Adding Paint Over the Ground
With a no. 4 filbert, start adding mixes of Cadmium Yellow Hue, Titanium White and Cadmium Orange Hue over the face, mane and ear. To keep the underdrawing slightly visible, wipe down heavy areas of paint with a rag.

7 Cover More of the Lion With Paint
Continuing with the no. 4 filbert and the paint colors from Step 6, paint over more of the lion. For darker regions, add Magenta and Phthalo Blue (Red Shade). As you add more paint, it will become heavier and more opaque, eventually covering the pencil lines of the underdrawing.

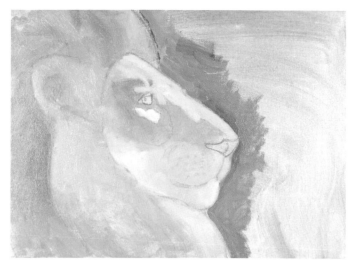

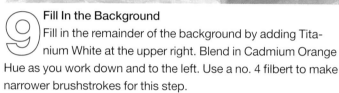

Start Painting the Background
With a no. 8 filbert, start painting the background along the profile of the lion with a mix of Cadmium Yellow Hue, Phthalo Blue (Red Shade), Titanium White and Permanent Rose.

Fill In the Background
Fill in the remainder of the background by adding Titanium White at the upper right. Blend in Cadmium Orange Hue as you work down and to the left. Use a no. 4 filbert to make narrower brushstrokes for this step.

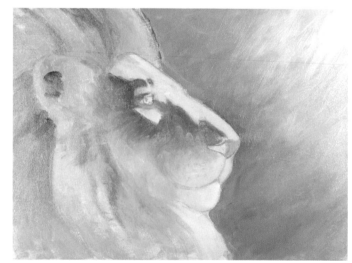

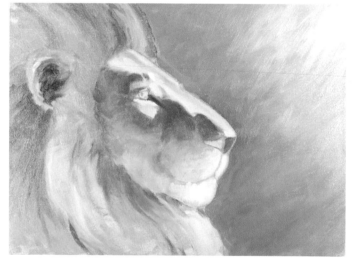

Develop the Colors of the Lion
Use a no. 4 filbert and mixtures of Cadmium Yellow Hue, Titanium White, Cadmium Orange Hue, Cadmium Red Hue, Permanent Rose, Magenta, Phthalo Blue (Red Shade), Burnt Sienna and Yellow Ochre to paint in the lion.

Continue Developing the Colors of the Lion
Continue building and developing the colors of the lion with a no. 4 filbert and the mixtures from Step 10. The paint can be mixed on the palette as well as mixed and moved on the canvas.

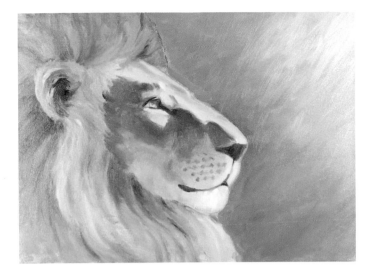

12 Start Adding Details and Adjustments

Using nos. 2 and 4 filberts, start adding details to the eye, nose and mouth, and darken the facial contours.

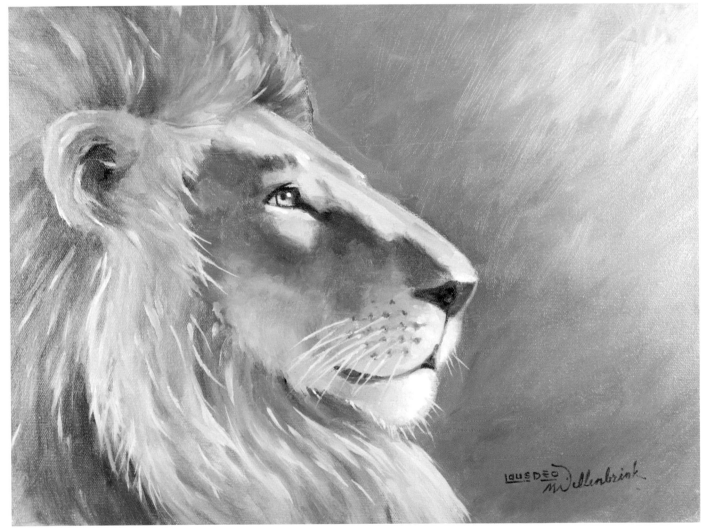

Regal
oil on stretched canvas
12" × 16" (30cm × 41cm)

13 Finish the Details and Adjustments

Add more details and subtle adjustments by lightening and darkening some of the fur and face. Add texture to the face by scumbling (see page 51). Smooth the fur in some places with a rag. Paint over the darker paint of the whiskers, hairs and fur clumps with a lighter mix of Titanium White and Cadmium Orange Hue using a no. 4 rigger and a no. 2 filbert. Add thinner to the paint to improve the flow. Let the painting dry, then sign and date it with a no. 4 rigger.

⃝ **Silhouettes**

Adding people to a scene creates a sense of connection with the viewer. The figures don't need to be highly detailed, especially if the rest of the scene is painted loosely. The important part is to make sure they are proportionally accurate and easy to identify. The simplest way to achieve this is to place them in silhouette form (see mini demonstration on page 105).

(see mini demonstration on page 105).

1 **Begin With Basic Structural Shapes**
With a 2B pencil, sketch the basic shapes of the arch and building.

2 **Add Structural Details**
Add details to the basic building shapes. Erase unwanted lines throughout the process.

The demonstration continues on page 106.

Materials

Surface
9" × 12" (23cm × 30cm) canvas on board

Paints
Burnt Sienna, Cadmium Orange Hue, Cadmium Red Hue, Cadmium Yellow Hue, Cadmium Yellow Light, Magenta, Phthalo Blue (Red Shade), Phthalo Green (Blue Shade), Sap Green, Titanium White

Brushes
no. 2 or ¼-inch (6mm) filbert
no. 8 or ½-inch (12mm) filbert
no. 2 round
no. 4 rigger

Other Supplies
palette, brush wash with water, palette knife, rag or paper towels, 2B or charcoal pencil, kneaded eraser, spray fixative, easel

Optional Supplies
thinner, medium, palette cups, mahl-stick, smock or apron

ART PRINCIPLES

• Linear Perspective (pages 28–29)

PAINTING TECHNIQUES

• Creating Brushstrokes (page 49)

Drawing People
MINI DEMONSTRATION

When drawing people, block in the basic features similar to a mannequin to develop the proportions and form.

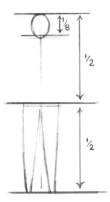

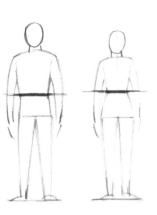

1 Draw Basic Proportions
Legs make up almost half the height of the average adult. Head size is a little more than one-eighth of the overall height.

2 Show Gender Differences
A major difference between men and women is the placement of the waist. Men have a lower waist, making for a larger torso. Women have a higher waist and fuller hips.

3 Add Movement
The appearance of movement, such as walking, can be added through subtle changes of the form. The straight legs are carrying the weight, and this affects the angles of the hips and shoulders, which are set at opposing angles.

4 Add Clothes and Hair
Add clothes, hair and costume elements to the blocked-in figures. The end result is two silhouetted figures that are easy to identify.

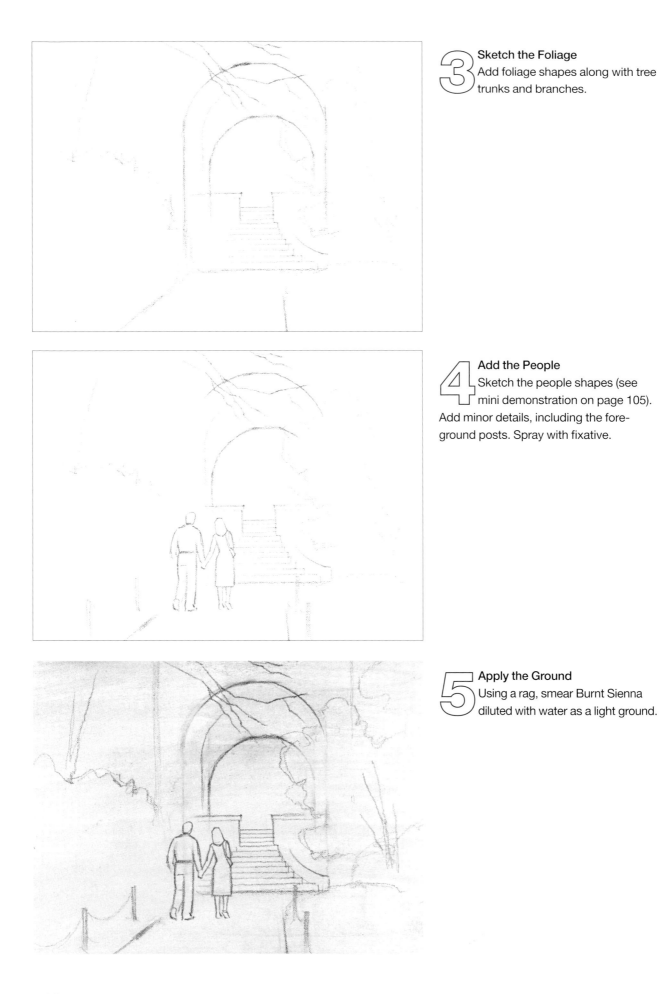

3 Sketch the Foliage
Add foliage shapes along with tree trunks and branches.

4 Add the People
Sketch the people shapes (see mini demonstration on page 105). Add minor details, including the foreground posts. Spray with fixative.

5 Apply the Ground
Using a rag, smear Burnt Sienna diluted with water as a light ground.

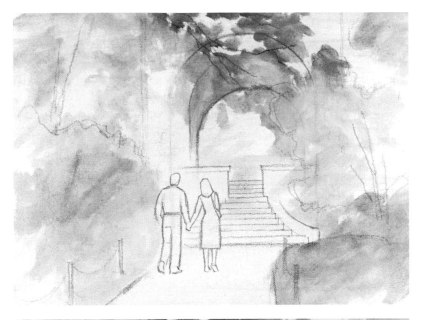

6 Add the Warm Underpainting Colors

With a no. 8 filbert, underpaint most of the foliage with mixtures of Cadmium Yellow Light, Cadmium Yellow Hue, Cadmium Orange Hue and Cadmium Red Hue. Apply paint thinly enough to allow the underdrawing to show through. These thin layers will be covered over with other paint layers.

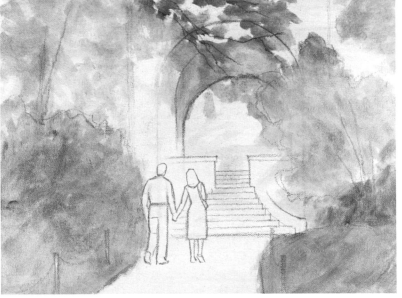

7 Add the Light and Midtone Greens

With mixtures of Cadmium Yellow Hue, Sap Green and Phthalo Green (Blue Shade), add the light and midtone greens of the foliage with a no. 8 filbert. The paint consistency is slightly thicker than that of the previous layer.

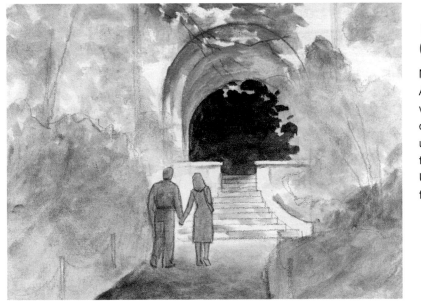

8 Add the Shadows and People

Add shadows to the foreground, building and people with a mix of Magenta and Phthalo Blue (Red Shade). Add Cadmium Yellow Hue to the mix for warm shadow colors in places such as the outer arch. There hasn't been any need to use Titanium White yet, because thinning the colors with water makes them lighter. Use a no. 8 filbert along with a no. 2 filbert for painting more precise details.

9 Start Painting Over the Foliage

Using a no. 8 filbert, start painting over the foliage with a mix of Phthalo Green (Blue Shade), Sap Green and Cadmium Yellow Light. Add Phthalo Blue (Red Shade) to the mix for darker places. From this stage on, use thicker, more opaque paint.

10 Continue Painting the Foliage

Using a no. 8 filbert, paint more foliage with the green mixtures from Step 9 along with warm mixtures of Cadmium Yellow Hue, Cadmium Orange Hue, Cadmium Red Hue and Titanium White. Paint the tree branches with a mix of Burnt Sienna and Phthalo Blue (Red Shade) using a no. 2 round.

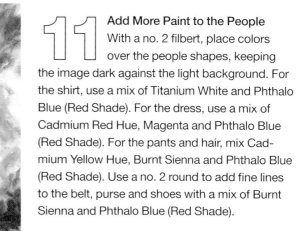

11 Add More Paint to the People

With a no. 2 filbert, place colors over the people shapes, keeping the image dark against the light background. For the shirt, use a mix of Titanium White and Phthalo Blue (Red Shade). For the dress, use a mix of Cadmium Red Hue, Magenta and Phthalo Blue (Red Shade). For the pants and hair, mix Cadmium Yellow Hue, Burnt Sienna and Phthalo Blue (Red Shade). Use a no. 2 round to add fine lines to the belt, purse and shoes with a mix of Burnt Sienna and Phthalo Blue (Red Shade).

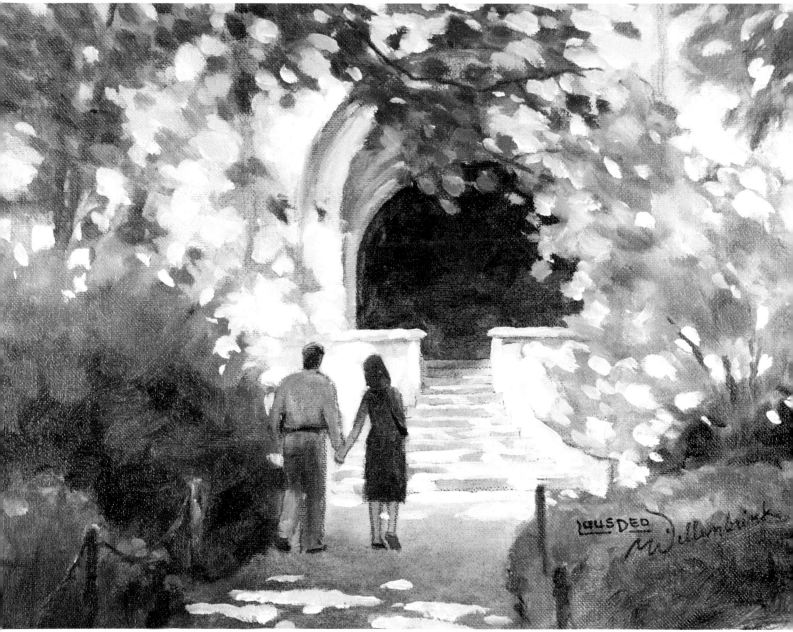

12 Add Light to the Building, Foreground and Final Details

Using a no. 2 filbert, paint over much of the building with a mix of Titanium White and Burnt Sienna. Make adjustments and add details, including the foreground posts and sunlight on the path. Let the painting dry, then sign and date it with a no. 4 rigger.

Garden Stroll
oil on canvas mounted on board
9" × 12" (23cm × 30cm)

Portrait in Profile

Portraits are both fun and challenging. A good portrait painting starts with an interesting subject. Proper lighting will help you to observe lights and darks and the fine details of the face.

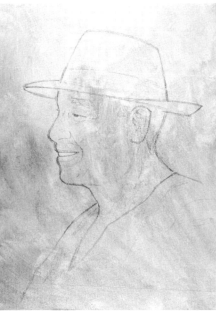

1 Draw the Profile
With a 2B pencil, draw the image directly onto the painting surface, following the mini demonstration on page 111. Include lines indicating features and shadow transitions.

Another method is to draw the image on a separate piece of paper, then copy it to the size you want. After that, transfer the image onto the painting surface using graphite paper.

With either method, spray with fixative to prevent the paint from smearing the graphite.

2 Add the Ground
Use a rag to smear Burnt Sienna diluted with water over the painting surface. The ground should be transparent so that the pencil lines remain visible.

The demonstration continues on page 112.

Materials

Surface
16" × 12" (41cm × 30cm) stretched canvas

Paints
Burnt Sienna, Burnt Umber, Cadmium Red Hue, Cadmium Yellow Hue, Cerulean Blue, Magenta, Permanent Rose, Phthalo Blue (Red Shade), Titanium White, Yellow Ochre

Brushes
no. 4 or ⁵⁄₁₆-inch (8mm) flat

no. 8 or ½-inch (12mm) flat

no. 2 round

no. 4 rigger

Other Supplies
palette, brush wash with water, palette knife, rag or paper towels, easel, 2B or charcoal pencil, kneaded eraser, spray fixative

Optional Supplies
thinner, medium, palette cups, mahlstick, smock or apron

ART PRINCIPLES

- Value (pages 30–31)
- Color Temperature (page 34)

PAINTING TECHNIQUES

- Creating Brushstrokes (page 49)

Drawing Profiles

Accurate proportions are essential to drawing and painting profiles. With subtle variations, this method can be used to draw almost any adult.

1 Draw the Basic Shape
Draw the basic profile shape slightly curved on the left side, then more curved on the top and right, then less curved at the bottom. A horizontal line halfway from the top and bottom indicates where the eye will be placed.

2 Add Lines for the Nose and Mouth
Add a horizontal line for the nose, placing it less than halfway down from the eye line to the chin. Add a line for the mouth, somewhat below the nose line.

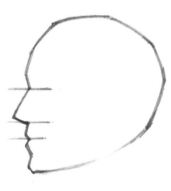

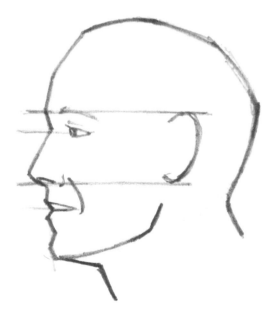

3 Form the Profile
Draw the form of the profile: go in at the eye line, out for the shape of the nose and again in for the mouth.

4 Add More Features
Add the individual features including the eye, nostril and mouth. The ear lines up with the eyebrow and base of the nose. The jaw is defined along with the neck. Finally, add hair and costume features.

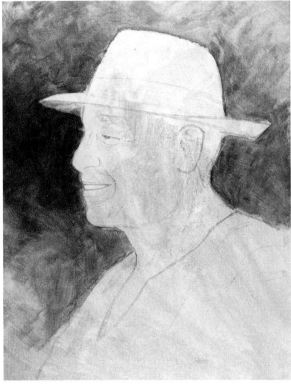

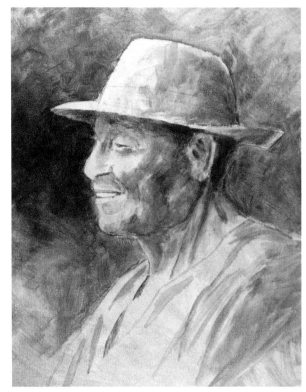

3 Add Washes of Burnt Umber to the Background

Using a no. 8 flat, add the values of the background with washes of Burnt Umber thinned with thinner or water. The background should be darkest on the left side to create contrast and emphasis on the face.

4 Add Washes to the Face and Clothes

Add values with washes of Burnt Umber to the face and clothes with a no. 8 flat. Use the tip for more detailed areas. Pull up excess paint with a dry no. 4 flat or wipe it away with a rag. The light source is in the upper left, so the left side of the subject will be lighter than the right.

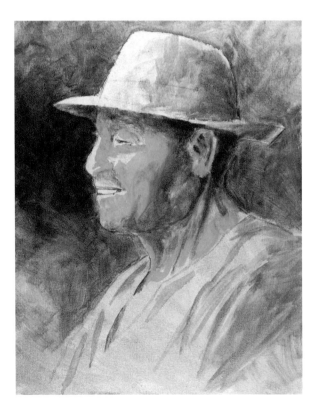

5 Add the Midtone Colors

Use a no. 8 flat and mixtures of Titanium White, Cadmium Yellow Hue, Cadmium Red Hue, Permanent Rose and Burnt Sienna to paint over the lighter areas of the face. Use paint that is thicker than the wash, but just thick enough to cover the previously applied paint.

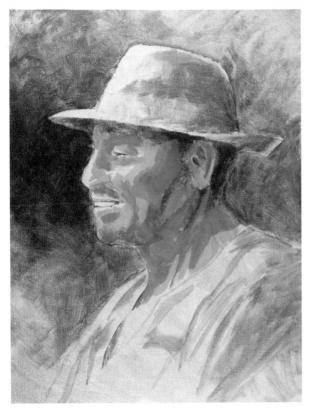

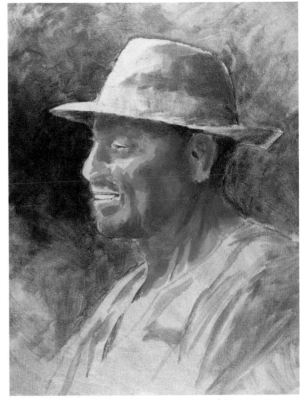

6 Add Slightly Darker Colors
Add more Burnt Sienna to darken the color mixtures from Step 5, then paint the hat and more of the face.

7 Keep Making the Colors Slightly Darker
Add more Burnt Sienna and some Cerulean Blue to the color mixtures from the previous steps and apply to the face and hat. The blue addition creates the cool color for the shadows.

8 Continue Making the Colors Darker
Add more Burnt Sienna and Phthalo Blue (Red Shade) to make the color mixtures even darker. For the most part, blend the paints together as you place them on the canvas.

The Beauty of the Different Hues
Take a minute to look in the mirror at your own flesh coloring. There are subtle differences of color in your face. Now look at your friend's facial coloring. When painting portraits, it is both fun and a challenge to mix the right colors. Take a few minutes to practice mixing flesh tones on a scrap of heavy paper or canvas.

9 Add Lights and Darker Colors
Using a no. 4 flat, add lighter areas of Titanium White and Yellow Ochre to the subject, including the hat. Blend the wet paint, smoothing out the form.

10 Add Warm Colors to the Hat and Shirt
Using a no. 8 flat, apply Titanium White and Yellow Ochre. Use Magenta for the reddish areas. Paint the hat and shirt looser and with less detail to draw the focus to the more detailed face.

11 Paint the Shirt and Background
Using a no. 8 flat, apply Phthalo Blue (Red Shade), Yellow Ochre and Titanium White to the shirt and background.

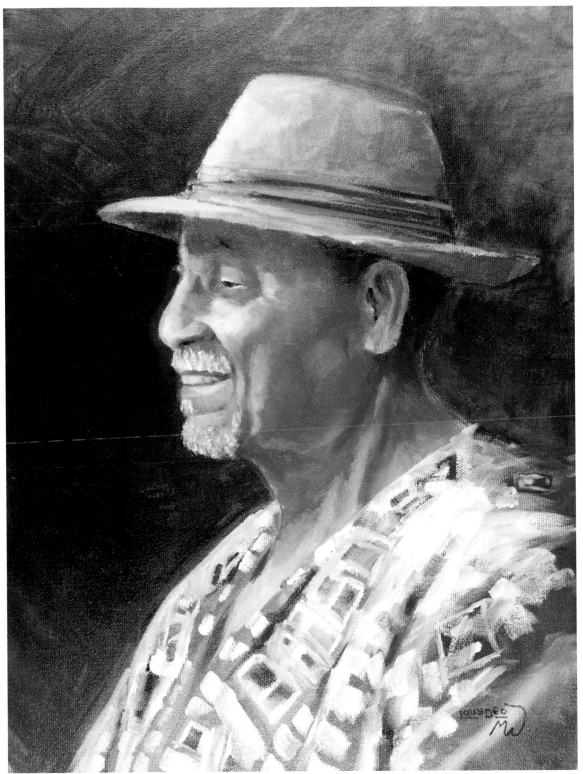

Mr. H
oil on stretched canvas
16" × 12" (41cm × 30cm)

12 Add the Final Lights, Darks and Details

Add and adjust the final lights, darks and details, including the hat, mustache, whiskers and shirt. Use nos. 4 and 8 flats and a no. 2 round for the details. Let the painting dry, then sign and date it with a no. 4 rigger.

A Mahlstick Makes It Easier

Try using a mahlstick to steady your hand while painting the details of this portrait.

Girl With Flowers

This demonstration captures the essence of childlike innocence. The warm colors in the foreground combined with the cool colors in the background emphasize depth.

Materials

Surface
14" × 11" (36cm × 28cm) stretched canvas

Paints
Burnt Sienna, Cadmium Yellow Medium, Cerulean Blue, Dioxazine Purple, Permanent Rose, Sap Green, Titanium White, Yellow Ochre

Brushes
no. 8 or ½-inch (12mm) flat
no. 2 or ¼-inch (6mm) filbert
no. 4 or 5/16-inch (8mm) filbert
no. 2 round
no. 4 round
no. 4 rigger

Other Supplies
palette, brush wash with water, palette knife, rags or paper towels, easel, 2B or charcoal pencil, kneaded eraser, spray fixative

Optional Supplies
thinner, medium, palette cups, mahl-stick, smock or apron

ART PRINCIPLES

• Color Temperature (page 34)

PAINTING TECHNIQUES

• Wet-Into-Wet (page 52)
• Wet-Into-Dry (page 53)

1 Draw the Head and Shoulders
Draw the basic shape of the head and shoulders using a 2B pencil. A line for the center of the face indicates the tilt of the head.

2 Add Arms, Neck and Hands
Add linework for the arms and neck. Draw circles for the hands.

3 Add Lines for the Face, Hair and Fingers
Add lines for the placement of the facial features, hair and fingers.

4 Add Details
Add overall details including the face, hair, dress and flowers. Erase unwanted lines. Spray with fixative.

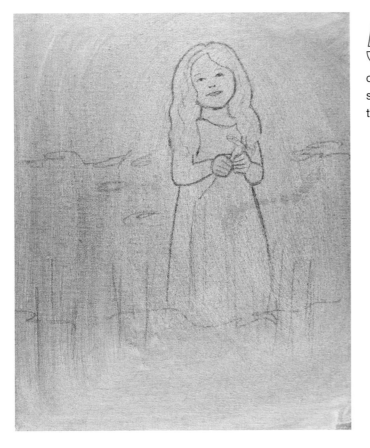

5 Add the Ground
For the ground, use a rag to smear Burnt Sienna diluted with water over the painting surface. The ground should be applied thinly enough to allow the pencil lines to remain visible.

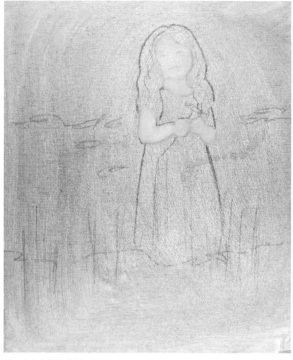

6 Add the Skin Tone

Using a mix of Cadmium Yellow Medium, Permanent Rose and Titanium White and a no. 4 filbert, paint over the face, neck, arms and hands. The paint thickness should allow the pencil lines to show through slightly.

7 Paint the Hair

Using a mix of Titanium White, Burnt Sienna, Yellow Ochre and Cadmium Yellow Medium, paint the hair with a no. 4 filbert.

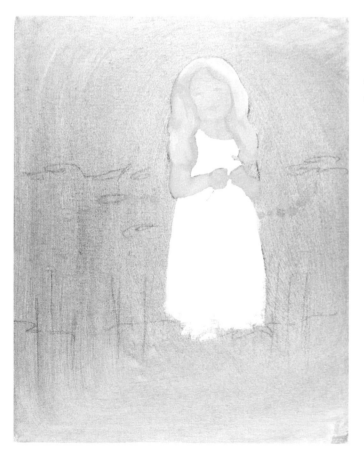

8 Paint the Dress

With a mix of Titanium White and Cadmium Yellow Medium, paint the dress using a no. 4 filbert. Use a no. 4 round or smaller brush for tight places. Some of this paint can be added to the hair.

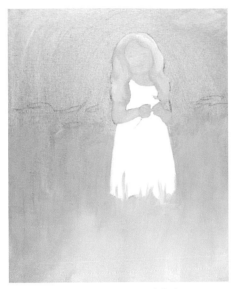

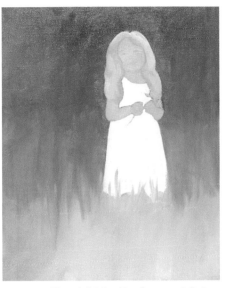

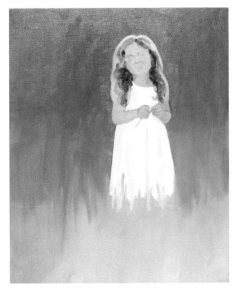

9 Add the Foreground Color
Add warm foreground greens with a no. 8 flat and a mix of Sap Green, Cadmium Yellow Medium, Titanium White and Permanent Rose.

10 Add the Background Color
Add cool background greens with a no. 8 flat and a mix of Sap Green, Cerulean Blue, Yellow Ochre, Dioxazine Purple and Titanium White.

11 Add Darks to the Skin, Hair and Dress
Add darks to the skin with a mix of Permanent Rose, Cadmium Yellow Medium and Titanium White, using a no. 2 filbert and a no. 4 round for details.
Add darks to the hair with a mix of Burnt Sienna and Yellow Ochre using a no. 2 filbert and a no. 4 round for details.
Add subtle darks to the dress with a mix of Titanium White and Dioxazine Purple, using a no. 2 filbert and a no. 4 round for details.

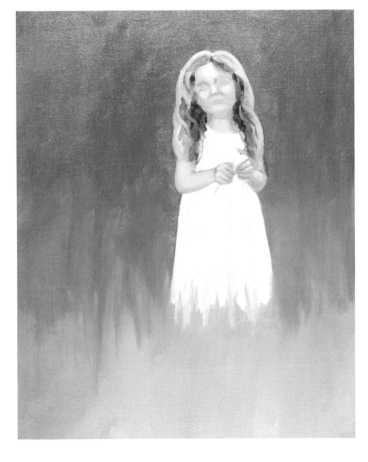

12 Add Lights to the Skin, Hair and Dress
Add warm lights to the skin, hair and dress with a mix of Titanium White and Cadmium Yellow Medium, using a no. 2 filbert and a no. 4 round for details.

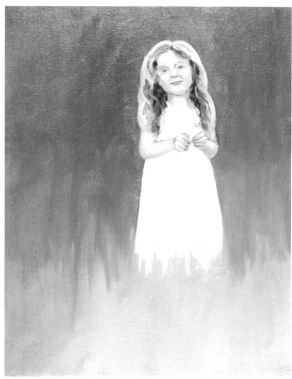

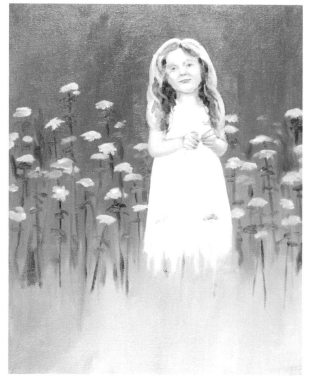

13 Add Details to the Face and Hands
With a mix of Permanent Rose, Cadmium Yellow Medium, Titanium White and Cerulean Blue, paint the details of the face and hands using nos. 2 and 4 rounds. Avoid overworking these areas. For the following steps, you may let the paint dry between steps, painting wet-into-dry instead of wet-into-wet. If you do, add a bit of medium to the paint.

14 Add Background, Flowers, Stems and Leaves
Paint the flower petals with a mix of Titanium White and Dioxazine Purple using a no. 4 filbert. Add the centers with a mix of Cadmium Yellow Medium and Titanium White using a no. 2 filbert. Paint stems and leaves with a mix of Sap Green, Cerulean Blue and Dioxazine Purple, using nos. 2 and 4 filberts.

Keep It Steady
Consider using the mahlstick when working with this portrait. It will help keep your hand steady.

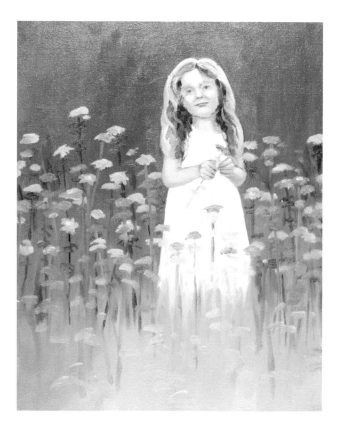

15 Add Foreground Flowers, Stems and Leaves
Paint the flower petals with a mix of Permanent Rose and Titanium White using a no. 4 filbert. Add the centers with a mix of Cadmium Yellow Medium and Titanium White using a no. 2 filbert. Paint the stems and leaves with a mix of Sap Green, Cadmium Yellow Medium and Titanium White, using nos. 2 and 4 filberts.

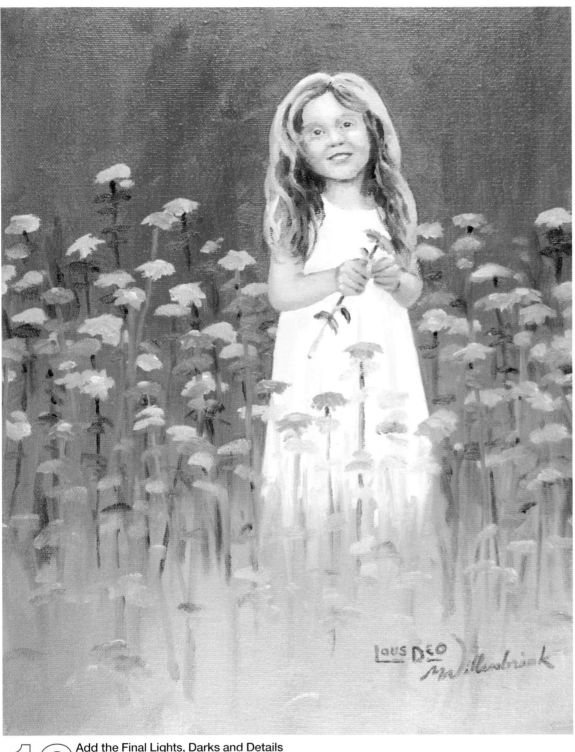

Girl With Flowers
oil on stretched canvas
14" × 11" (36cm × 28cm)

16 Add the Final Lights, Darks and Details

Add and adjust final lights, darks and details including face, hair, flowers and foreground using a variety of brushes and colors. Let the paint dry, then sign and date it with a no. 4 rigger.

Finishing Your Paintings

Once you have completed your fine art, you need to prepare your painting for display and longevity. Adding varnish and a frame may not seem important now, but, once you have completed these steps, you will see your painting in a whole new light. It will have a more finished, professional look that will make you proud of your masterpiece.

Drying and Storing Paintings

Before applying varnish, the painting surface must be free of dust and thoroughly dry. Drying requires six to twelve months or longer depending on the thickness of the paint. Store oil paintings vertically to prevent dust from collecting on them both before and after they've been varnished.

Applying Varnish

Varnish is a clear liquid available in both bottles and spray cans. Applied over oil paintings, varnish acts as a barrier from dust and grease and also provides a uniform finish to the painting surface. Some varnishes are removable, allowing for the option of cleaning the painting if it becomes dirty over time.

Varnish can be sprayed on or brushed on with the thin, even strokes of a wide brush. Whether spraying or brushing, always follow the manufacturer's recommendations and guidelines. If you brush on varnish, you'll need turpentine or mineral spirits to clean the application brush unless the varnish is water-soluble, in which case it will clean up with soap and water.

Framing Your Painting

Frames should complement the art and express the general theme without distracting from the art itself. Some artists include a nameplate on the front of the frame that states the title of the art piece as well as their name. The back may be covered with a sheet of craft paper, which acts as a dust cover. *Bumpers* keep the frame from resting directly against a wall and allow air to circulate around the painting to prevent mold. You may want to place a sticker stating the artist's information on the back.

Varnish Options
Varnish is available in bottles or spray cans. Spray cans are convenient. However, I prefer to apply water-soluble varnish with a brush because it makes cleanup easy. When using bottled varnish, designate a brush specifically for the application of the varnish so that you won't damage your good painting brushes.

The Right Match
Choosing the right frame will enhance your painting's appearance and give it a more professional, finished look.

Lookin' Good!
A painting that is framed well will look clean and professional, even from the back.

Conclusion

This is only the beginning. If you are one of those methodical people (like Mark) and you've worked through this book from cover to cover, now it's time to revisit some of your favorite areas. Or, if you're one of those people (like Mary) who use the "amount of effort vs. potential for success" formula to guide your work, you're ready for some of the more challenging aspects of this book. Have fun and keep up the good work!

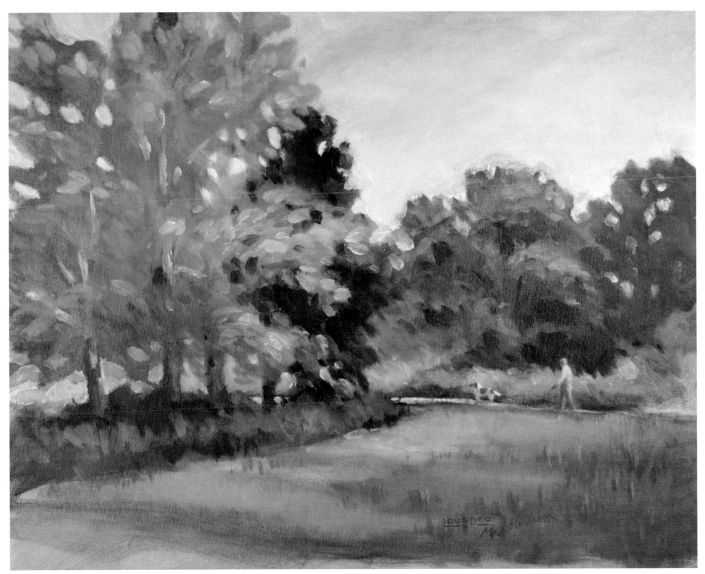

Evening Walk
oil on stretched canvas
16" × 20" (41cm × 51cm)

Glossary

A

Alla prima: Italian for "at first," referring to an immediate application of paint.

Analogous colors: a range of colors adjacent to each other on the color wheel, such as blue-green, blue, blue-violet and violet.

Asymmetrical: that which is not symmetrical. In reference to art, something may be balanced without being symmetrical.

Atmospheric perspective: the illusion of depth achieved through contrasts in value and definition.

B

Bamboo brush holder: a bamboo mat used to store paint brushes.

Binder: a paint ingredient that binds the pigment particles. Oil is the binder in oil paint.

Brush wash: a jar filled with water or solvent that is used to wash paint out of brushes.

C

Canvas pad: sheets of primed canvas in pad form.

Color intensity: the potency or strength of a color, also referred to as saturation.

Color palette: the colors used in a painting.

Color temperature: the differentiation between warm or cool colors.

Color wheel: a circular chart showing the primary, secondary and tertiary colors and how they relate to one another.

Complementary colors: two colors that appear opposite each other on the color wheel, such as red and green.

Composition: the arrangement of elements involving structure, value and color, that provides a path for the eye to follow through the painting.

Contrast: the extreme differences between specific elements in a painting, most commonly used to discuss value.

Cool colors: colors that look cool, such as green, blue and violet, also referred to as recessive colors.

E

Easel: a stand to prop artwork.

F

Fan brush: a brush with a fanlike shape to its bristles.

Fat over lean: a method of painting that involves layering more oily paint over less oily paint.

Filbert brush: a brush head with a flat shape and rounded tip that may come to a point.

Flat brush: a brush head with a flat shape and squared tip.

G

Gesso: a primer used to coat the painting surface before painting.

Glazing: to apply thin, transparent paint in layers.

Graphite paper: thin paper covered with graphite on one side, used to transfer drawings or images.

Ground: a layer of color applied to a canvas prior to the painting process.

H

Hard edge: the sharply defined, unblended edge of a wash or stroke of paint.

Highlight: an area of reflected light on an object.

Horizon: the line where land or water meets the sky, in reference to linear perspective.

I

Impasto: Italian for "paste" or "dough," refers to a thick application of paint.

K

Kneaded eraser: a soft, pliable gray eraser.

L

Lightfastness: the degree to which a paint resists fading.

Light source: the origin of the light shining on elements in a composition.

Linear perspective: depth implied through line and the relative size of elements.

M

Mahlstick: a stick with a cork covered in leather on the end, used as a hand rest for steadier painting.

Medium: a liquid or gel paint additive that changes the characteristics of the paint.

Mineral spirits: a solvent used to thin and dilute traditional oil paints.

Monochromatic: one color.

N

Negative painting: painting around shapes or elements to imply their forms.

O

Oil paint: paint that uses oil as its binder.

One-point perspective: a type of linear perspective that uses one vanishing point.

P

Painting surface: the canvas, linen or panel that is painted on, also called a support.

Palette: a tray or disposable pad of paper for holding and mixing paints during a painting session.

Palette cups: small cups that clip onto the palette to hold thinner and medium.

Palette knife: a spatula-like knife used to mix paint on and clean paint off the palette and to add and remove paint from the painting surface.

Palette pad: a pad of disposable paper used as a palette for holding and mixing paint.

Pigment: the ingredients that give color to paint.

Positive painting: painting an element on a background, as opposed to negative painting.

Primary colors: the three basic colors, red, yellow and blue, from which all other colors are derived.

Professional (artist) grade paint: high-quality paint.

R

Rigger brush: also called a script or liner, a type of round brush with thin, long hairs.

Round brush: a paintbrush with hairs that come to a point.

S

Scumbling: to apply undiluted paint over previously applied paint, allowing some of the previously applied paint to show through.

Secondary colors: the three colors, orange, green and violet, made from a combination of two of the three primary colors.

Soft edge: a paint edge that smoothly blends into the surrounding paint.

Spray fixative: a spray coating used to prevent graphite or charcoal from smearing.

Stretched canvas: a painting surface made from canvas stretched over a frame of stretcher bars.

Stretcher bars: the wood frame pieces of a stretched canvas.

Student grade paint: usually less expensive paint that is lower quality than professional (artist) grade paint.

Symmetrical: balanced composition, with equal elements placed as if reflected in a mirror.

T

Taboret: an artist supply cabinet.

Tangent: the meeting of two compositional elements. Tangents usually detract from a composition.

Tertiary colors: the colors made from combinations of one primary color and one secondary color, such as blue-violet.

Thick over thin: the process of applying thicker paint over thin paint.

Traditional oil paints: oil paints that usually require solvents, such as turpentine or mineral spirits, to thin and dissolve the paint.

Turpentine: a solvent used to thin and dilute traditional oil paints.

Two-point perspective: a type of linear perspective that uses two vanishing points.

U

Underdrawing: drawing directly onto the painting surface as a guide for the placement of the paint.

Underpainting: a monochromatic wash of paint on the painting surface used as a preliminary guide.

Unprimed canvas: canvas that does not have a layer of primer or gesso.

V

Value: degrees of lightness or darkness of a color.

Value scale: a scale showing the range of values of a color.

Vanishing point: a point on the horizon line at which parallel lines seem to converge.

Vantage point: the point from which the viewer observes a scene.

Varnish: a clear liquid applied over a dry painting as a protective coating.

Viewfinder: a device used to visually crop a scene.

W

Warm colors: colors that look warm, such as red, orange and yellow, also referred to as aggressive colors.

Wash: a transparent application of paint.

Water-soluble oil paint: oil paint that can be thinned and diluted with water.

Wet-into-dry: applying a layer of paint on a layer of dry paint.

Wet-into-wet: applying a layer of wet paint into a layer of wet paint.

Index

Ideas. Instruction. Inspiration.

Painting Oil Portraits in Warm Light with Chris Saper
DVD • 102 minutes, Z7274
ISBN-13: 978-1-4403-0523-8

In this workshop, Chris gives you lessons on mixing colors for skin tones and shadows in warm light. All light has color, and the light you choose to illuminate your subject with dictates every color decision you'll make in both light and shadow. Just follow along with the step-by-step instruction and you'll be painting beautiful portraits in no time!

Watercolor for the Absolute Beginner
by Mark and Mary Willenbrink
ISBN-13: 978-1-60061-770-6
Paperback, 128 pages, Z4978

Even if you've never picked up a brush, you will be amazed at how easy it is to complete your first watercolor project. This book walks you through such essential topics as materials, value, color and composition. There are also helpful demonstrations on proper brush technique and planning a painting. This new edition includes a bonus DVD to review basic techniques in action!

The Artist's Magazine

The Artist's Magazine celebrates the creative life and the creative act, the artist as well as the art, by showcasing the best work—in all media and in all styles—of the best artists working today. Find the latest issue on newsstands, or order online at www.artistsnetwork.com/magazines.

These and other fine North Light products are available at your local art & craft retailer, bookstore or online supplier. Visit our websites at **www.artistsnetwork.com** and **www.artistsnetwork.tv**.

Visit www.artistsnetwork.com and get Jen's North Light Picks!
Get free step-by-step demonstrations along with reviews of the latest books, videos and downloads from Jennifer Lepore, Senior Editor at North Light Books and Online Education Manager.